In the Darkroom

Sarah Kennel

with Diane Waggoner
and Alice Carver-Kubik

National Gallery of Art
Washington

Thames & Hudson

In the Darkroom

An Illustrated Guide
to Photographic Processes
before the Digital Age

This publication is made possible by a generous grant from
The Robert Mapplethorpe Foundation, Inc.

First published in paperback in the United States of America in 2010 by Thames & Hudson Inc., 500 Fifth Avenue, New York, New York 10110

thamesandhudsonusa.com

First published in the United Kingdom in 2010 by Thames & Hudson Ltd, 181A High Holborn, London WC1V 7QX

www.thamesandhudson.com

Library of Congress Catalog Card Number: 2009934446

British Library Cataloguing-in-Publication Data: A catalogue record for this book is available from the British Library

ISBN 978-0-500-28870-2

10 9 8 7 6 5 4 3 2 1

Produced by the Publishing Office, National Gallery of Art, Washington
www.nga.gov

Judy Metro, *Editor in Chief*
Chris Vogel, *Deputy Publisher and Production Manager*
Sara Sanders-Buell, *Photography Rights Coordinator*
John Long, *Assistant Production Manager*
Daniella Berman, *Program Assistant*

Designed by Margaret Bauer
Edited by Mary Yakush
Separations by Robert J. Hennessey
Diagrams by Martha Vaughan

Works of art owned by the National Gallery of Art have been photographed by Lorene Emerson, David Applegate, Dean Beasom, Ricardo Blanc, and Lee Ewing, Division of Imaging and Visual Services.

This book was typeset in Meta and Adobe Caslon Pro and printed on 150 gsm Satimatt Naturelle at Legatoria Editoriale Giovanni Olivotto in Vicenza, Italy.

Contents

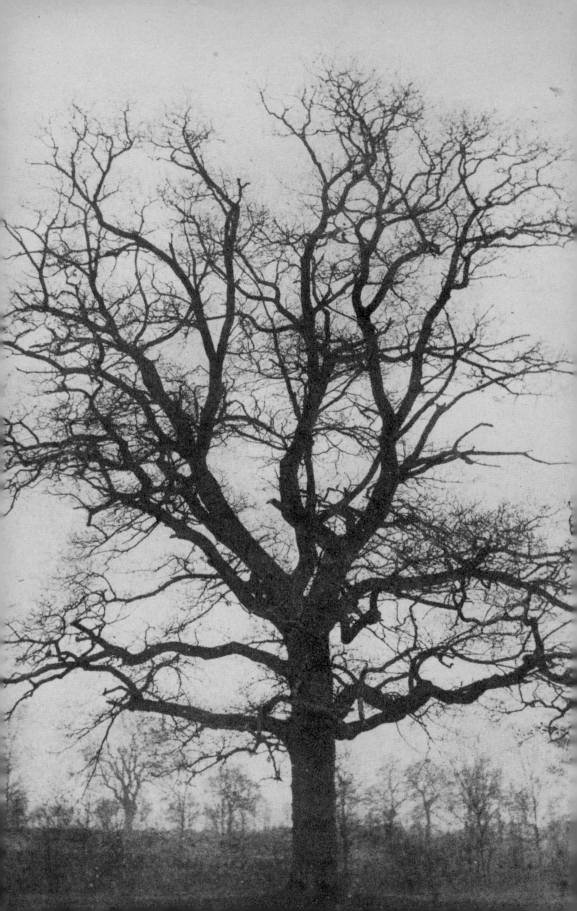

Introduction

Sarah Kennel

How charming it would be if it were possible to cause these
natural images to imprint themselves durable and remain fixed
upon the paper! And why should it not be possible?

WILLIAM HENRY FOX TALBOT, *The Pencil of Nature*, 1844

In the more than 170 years since the early efforts of William Henry Fox Talbot
and others to "fix" images on paper, photographers and others have not only
demonstrated that this is possible but have also invented numerous different
processes for doing so. Photographic images have usually (but not always)
been produced in a camera, a light-tight chamber with an opening (aperture),
often fitted with a lens and a shutter, through which an image is projected
and recorded on a light-sensitive surface. No single formula exists for making
a photograph, but the twenty-seven photographic and photomechanical
processes that are the subject of this book share three basic requirements:
materials that behave predictably in response to light, chemicals that control
and fix the action of light to produce an image, and a support upon which the
image rests. Whether by varying the chemical formulas that render materials
sensitive to light, exploring different methods of development and printing,
or experimenting with negative and print supports, photographers (and com-
mercial manufacturers) have made photography a rich, complex, and manifold
set of practices. It includes artistic, scientific, commercial, and documentary
work in an enormous variety of formats. Of course, the selection and execution
of a photographic process are shaped by many factors, including the available
technologies, the nature of the photographic work, the historical conditions
of production, and the talents and aims of the individual photographer.

1

This book provides an introduction to the most commonly used photographic processes from the origins of the medium in the late 1830s until the end of the twentieth century, when digital technology for capturing and transmitting visual images gradually superseded processes that rely upon chemicals to control the action of light. The processes discussed here generally fall into one of three categories: negative-positive, direct positive, and photomechanical. A negative is made by exposing an image onto a light-sensitive material, which results in the reversal of light and dark tones. Unless the photographer uses special equipment, such as mirrors or reversing prisms in the camera, the negative is also laterally reversed from the original subject. Any number of positive, or "tonally correct," prints can be made by exposing the negative's image onto another light-sensitive support, which again reverses its tones to create a tonally correct image. This also corrects the lateral reversal, so that the positive print represents the correct orientation of the original subject. "Direct positives" include unique photographs that are the result of a single exposure on a light-sensitive surface. They do not produce a negative and, as such, generally cannot be reproduced unless they are rephotographed. A photograph can also be reproduced with ink on paper, by transferring the image to a specially prepared metal or glass plate and printing it with traditional graphic arts methods. Processes that render photographs in this manner are called photomechanical processes. Born of a desire to make photographs that were less susceptible to fading, they are among the most permanent forms of photographic images.

Concise explanations of the predominant negative, positive, and photomechanical processes in use since 1839 are arranged here in alphabetical order. Descriptions of the technical processes, their most common uses, and general characteristics are intended to aid the reader in identifying the processes used to make specific photographs. Each process is illustrated with a representative photograph, accompanied by a drawing that shows the various layers of image-bearing photographic materials on a support. In some cases a detail of a photograph, made at high magnification, is included to convey specific characteristics of the process, such as surface texture or image pattern.

We do not include every process invented, nor do we explore the myriad variations and improvements to each process that individual photographers and manufacturers developed over the years. It would be impractical to catalogue all modifications, both to the chemical formulas and the physical manipulations, that occurred over time as photographers sought to achieve their desired aesthetic and technological aims. Because many processes were built upon previous inventions and discoveries and because the history of photography continues to evolve, the secure identification of a process's inventor or its exact date of invention is not always possible. Where information is available, we have followed generally accepted identifications and

dates. A list of suggested reading is provided at the end of this book for those who wish to explore further the history or technical aspects of photographic processes.

Finally, although many of the processes in this book are described as historical, we must note that even as digital photography becomes the norm, many photographers choose to continue to work in older (sometimes called "alternative") processes. The contemporary use of historical processes in photography is a rich and fascinating phenomenon that greatly increases our understanding of the challenges that the earliest photographers faced and deepens our appreciation for their achievements.

Note to the Reader: Within the entry for each process, references to other processes discussed in this book are marked in a bold, colored type that corresponds to the color used for the alphabetical listing in the table of contents. Commonly used terms are defined in a glossary at the back of the guide. A time line signaling the dates of major use for each process follows on pages 4 and 5 and is also included on the inside back flap for convenient reference.

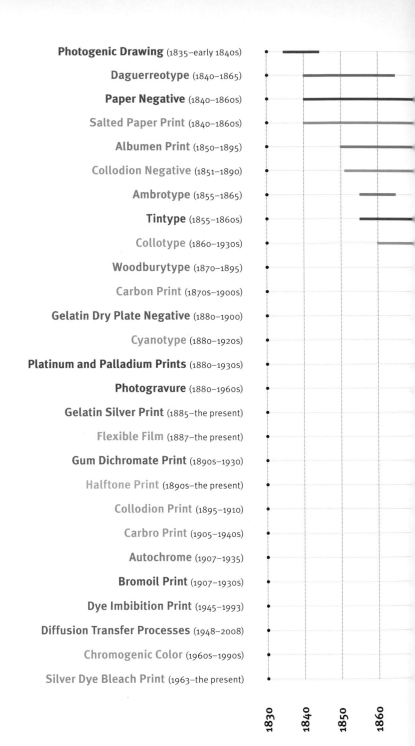

Photogenic Drawing (1835–early 1840s)

Daguerreotype (1840–1865)

Paper Negative (1840–1860s)

Salted Paper Print (1840–1860s)

Albumen Print (1850–1895)

Collodion Negative (1851–1890)

Ambrotype (1855–1865)

Tintype (1855–1860s)

Collotype (1860–1930s)

Woodburytype (1870–1895)

Carbon Print (1870s–1900s)

Gelatin Dry Plate Negative (1880–1900)

Cyanotype (1880–1920s)

Platinum and Palladium Prints (1880–1930s)

Photogravure (1880–1960s)

Gelatin Silver Print (1885–the present)

Flexible Film (1887–the present)

Gum Dichromate Print (1890s–1930)

Halftone Print (1890s–the present)

Collodion Print (1895–1910)

Carbro Print (1905–1940s)

Autochrome (1907–1935)

Bromoil Print (1907–1930s)

Dye Imbibition Print (1945–1993)

Diffusion Transfer Processes (1948–2008)

Chromogenic Color (1960s–1990s)

Silver Dye Bleach Print (1963–the present)

1830 1840 1850 1860

Time Line

(Dates of Major Use)

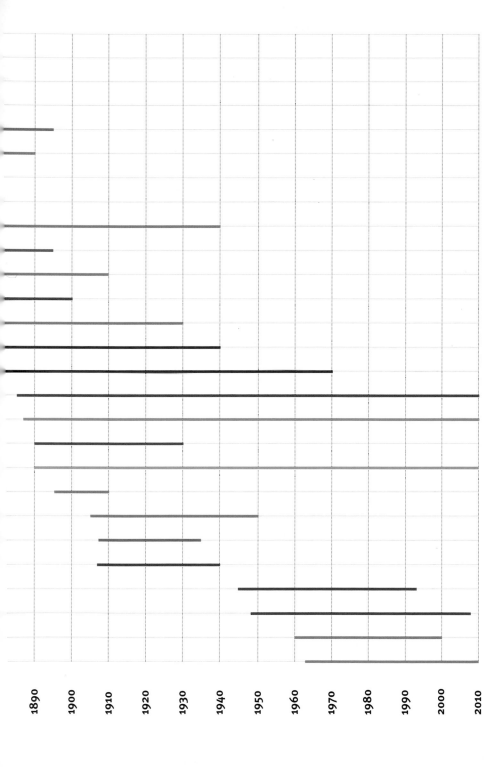

1890 1900 1910 1920 1930 1940 1950 1960 1970 1980 1990 2000 2010

Photographic
Processes

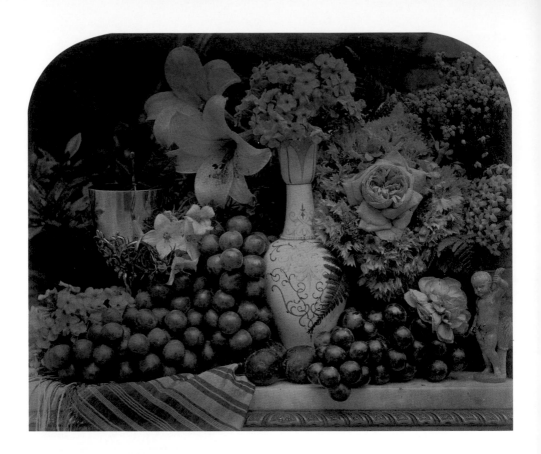

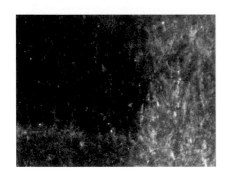

Albumen Print / Widely adopted by amateur and professional photographers alike, this process dominated both art and commercial photographic printing in the second half of the nineteenth century and was often used for making *cartes-de-visite,* cabinet portrait photographs, and stereoscopic prints. The albumen print possessed a sharper image and a wider range of tones than its predecessor, the salted paper print. Photographers prized the albumen print's rich density and, when coupled with the collodion negative, its capacity to render fine detail.

Albumen paper is made by coating a thin paper stock with a mixture of ammonium or sodium chloride, and albumen (fermented egg white, often with acetic acid added). After drying, the paper is floated on a silver nitrate bath to sensitize it to light. It is then dried a second time, placed in a printing frame in direct contact with the negative, and exposed to sunlight to print out. After exposure, the paper is rinsed in water to wash out the excess silver salts, and usually immersed in a gold toning solution and washed again. Last, it is placed in a bath of fixer, usually sodium thiosulfate, washed again, and then hung to dry.

The albumen binder, which holds the silver image, rests on top of the paper fibers, giving albumen prints their characteristic smooth, glossy finish. Starting in the 1880s, most commercial albumen prints were also either burnished or placed through a roller mechanism after mounting to increase their smoothness and sheen. Some photographers, preferring a matte finish, diluted the albumen before coating their papers. Closer in appearance to a salted paper print but with greater depth, these are sometimes called lightly albumenized salted paper prints. Matte papers with arrowroot or another starch added to the albumen coating became available in the 1890s. These should not be confused with arrowroot prints, which are a form of salted paper print in which the binder material is made from a paste of boiled arrowroot starch and contains no albumen. →

ALBUMEN PRINT

Dates of Major Use:
1850–1895

Type: positive print
(printed-out)

Inventor: Louis
Désiré Blanquart-
Evrard (1850)

Variant Names/
Related Processes:
albumen silver print

Roger Fenton, *Fruit
and Flowers*, 1860,
albumen print

Magnification shows the
fibers of the paper support through the glossy
albumen binder.

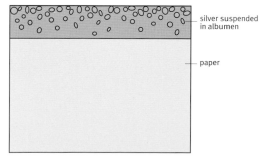

silver suspended
in albumen

paper

ALBUMEN PRINT

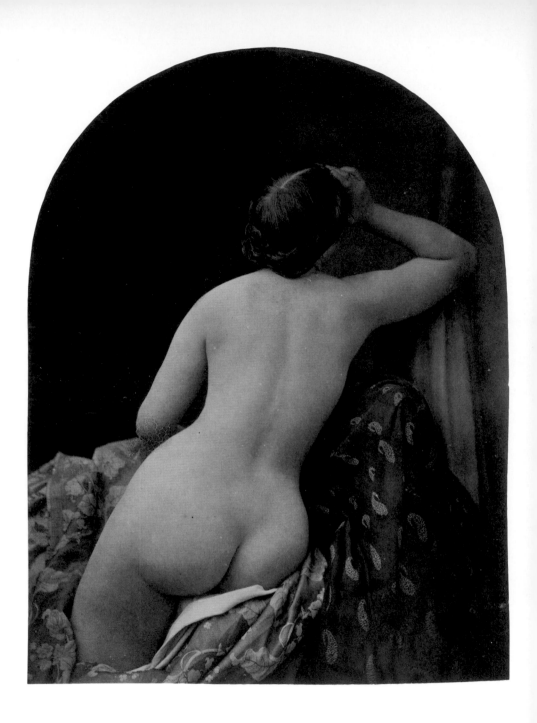

10

Because their highlights tend to yellow over time, most albumen prints were toned with gold, which generally enhances image permanence and enriches tonal density. Gold toning also changes the image hue from reddish to the rich, purplish hue that nineteenth-century viewers preferred. To further counter yellowing, papers tinted with pink, green, or blue dyes (all highly fugitive) appeared in the 1860s, becoming especially popular for studio portraiture in the 1870s and 1880s.

The albumen coating contracts while drying, causing the thin paper to curl upward at the edges, so albumen prints were usually mounted on boards or card stock. Usually printed from collodion negatives, most were trimmed to eliminate the visible edges of the negative and the non-image areas at their corners. Over time, loss of detail in the highlight areas can be dramatic. Another trait, especially of mounted prints or prints in albums and books, is the tendency to fade from the outside edges inward. Subject to spots and some silver mirroring, the albumen layer is also prone to surface cracking.

Oscar Gustave Rejlander, *Ariadne*, 1857, albumen print

Eugène Atget, *Etang de Corot (Corot's Pond), Ville-d'Avray*, 1900–1910, matte albumen print

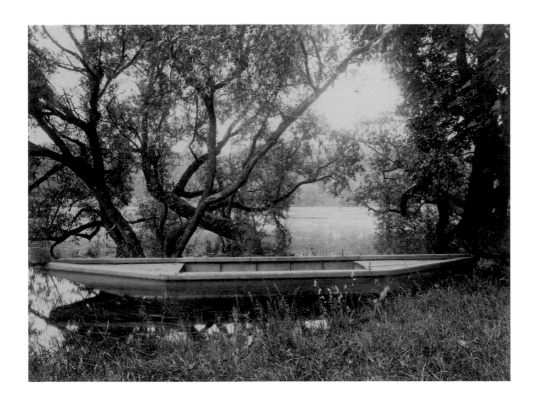

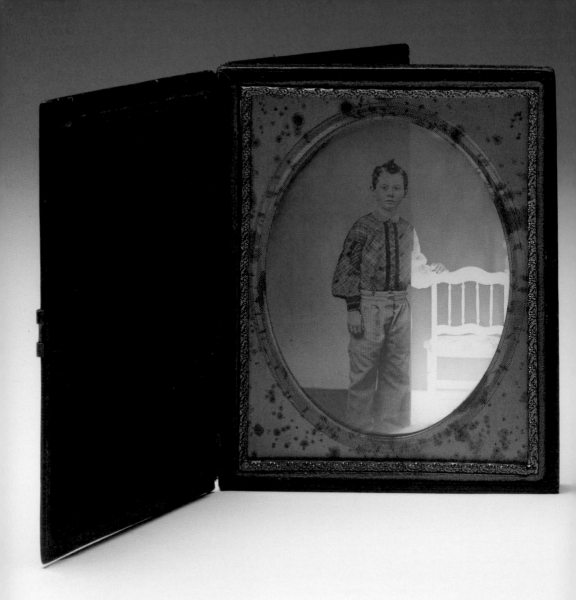

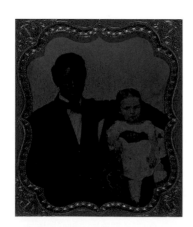

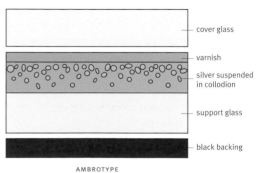

— cover glass

— varnish

— silver suspended
in collodion

— support glass

— black backing

AMBROTYPE

Ambrotype / This direct positive, made on a glass plate, resulted from the discovery that an underexposed collodion negative would appear as a positive when viewed against a dark ground. The process is also called the collodion positive process. Ambrotypes were a cheaper, faster alternative to **daguerreotypes** and were especially popular for studio portraiture. The ambrotype's use peaked during the second half of the 1850s and waned after the popularization of the less expensive **tintype** and albumen *carte-de-visite* portrait.

As with the collodion negative, potassium iodide and bromide are added to collodion, which is then evenly poured onto a cleaned glass plate. The coated plate is immersed in a silver nitrate bath to sensitize it to light, immediately placed in a plate holder, and put into the camera. After exposure, the plate is removed from the plate holder, and the developer is poured onto the plate to make the latent image visible. It is then immersed in a sodium thiosulfate bath to fix the silver image and is washed and dried. Last, a coating of varnish is applied to protect the collodion. Because a thinner, less dense image is better suited to this process, the exposure time is less than that for a collodion negative.

After varnishing, the back of the glass plate is painted with black lacquer, or a dark background — usually cloth or paper — is placed behind the plate. When viewed in transmitted light without the dark backing, the typically milky gray-white image is seen as a negative. But with the dark backing, the positive and negative tones are reversed and the image appears as a positive. Some ambrotypes made on dark-colored glass, often red (called ruby glass), did not require the dark background. Still others have a dark backing applied to the collodion side to correct the lateral inversion of the image. In another variation, only the image area is backed by the dark color, giving a relief effect; these are sometimes referred to as relievo ambrotypes.

Made in a range of plate sizes, ambrotypes were usually framed or housed in fabric-lined cases that were covered with leather or paper or made out of thermoplastic (an early type of plastic). A protective cover glass and a brass preserver and mat hid imperfections of the collodion along the edges of the plate. Photographers sometimes hand-colored the faces, hands, drapery, or even the entire ambrotype.

AMBROTYPE

Dates of Major Use:
1855–1865

Type: direct positive

Inventor: Frederick Scott Archer (1852), J. Ambrose Cutting (1854)

Variant Names/ Related Processes: collodion positive

American, 19th century,
George E. Lane, Jr.,
c. 1855, ambrotype

Some ambrotypes were mounted in cases that opened from the front and back, with dark lining that made it possible to view the image from either side. This ambrotype is displayed partially open in order to show the image as both a positive and a negative.

American, 19th century,
Portrait of a Man and Child, 1850s, ambrotype

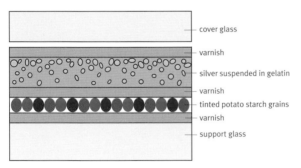

cover glass

varnish

silver suspended in gelatin

varnish

tinted potato starch grains

varnish

support glass

AUTOCHROME

Autochrome / The first commercially successful color photographic process, patented in 1903 by Auguste and Louis Lumière and introduced to the public in 1907, the Autochrome met with success among amateur and professional photographers alike. The softness of the image and natural yet subdued color quality attracted art photographers, particularly those associated with the pictorialist movement, while simple processing allowed the amateur to develop plates at home. Photojournalists also embraced Autochromes, which could be reproduced as color halftone prints. It was the most popular of the screen plate processes, which are based on the principle that a full-color image can be made by combining different amounts of the three primary additive colors: red, green, and blue. If a screen made up of these colors is placed in front of a sensitized plate or film, the screen will transmit only the light corresponding to those colors and absorb the rest. The negative can then be used to make a positive transparency, which, when placed in registration with an identical colored screen and viewed with transmitted light, appears as a full-color image.

The Autochrome "package" consists of a screen made up of miniscule potato starch grains dyed red-orange, green, and blue-violet, adhered to a glass plate. After varnishing the screen to protect the water-soluble dyes In the starch layer, the manufacturer applied a panchromatic, black-and-white gelatin silver bromide emulsion. During exposure, only red, green, and blue light reached the plate, owing to the screen. When developed, the plate bore a negative image, which was subsequently bleached and redeveloped to create a positive black-and-white image behind the color screen. After the package was sealed around the edges with black paper tape, it could be viewed by transmitted light, either by holding the plate up to light, projecting it, or placing it in a special viewer called a diascope. The combination of the positive black-and-white image and the color screen resulted in a full-color image.

The Lumière brothers' process achieved immediate, widespread success. Demand for commercially produced Autochrome plates, which came in a variety of sizes, was high. However, the process had limitations: the slow exposure time, the high cost of plates, and the inability to manipulate or duplicate the plates physically or chemically. Sometimes the dyed starch grains clumped together, creating random spots of color. Despite its drawbacks, the Autochrome remained the most successful color process until the 1930s, when chromogenic color film superseded it. Autochromes are rarely exhibited because the dyes are extremely susceptible to fading from exposure to light.

AUTOCHROME

Dates of Major Use:
1907–1935

Type: direct positive transparency, additive color

Inventor:
Auguste and Louis Lumière (1903)

———

Alfred Stieglitz, *Unknown Woman*, 1907, Autochrome

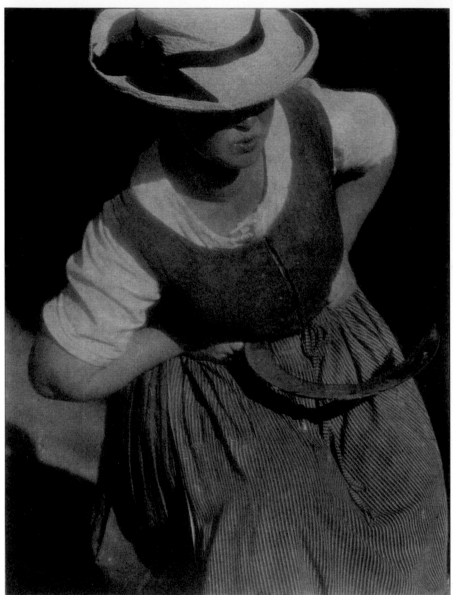

ink

paper

BROMOIL TRANSFER PRINT

Bromoil Print

Bromoil Print / Popular with serious photographers and favored by many in the pictorialist movement well into the 1920s, bromoil prints, which were introduced in 1907, usually exhibit a soft, textural quality and subtle gradations of tone without hard edges or contrasts, and resemble lithographs. Produced with lithographic inks, bromoil and bromoil transfer prints were amenable to manipulation by the photographer, could be made in a wide range of colors, and had strong image permanence.

To make a bromoil print, the photographer begins with an exposed bromide print (a type of **gelatin silver print**), which is placed in a bleaching and tanning solution containing potassium dichromate mixed with other chemicals. The darkest areas, where silver is the densest, will harden the most, the highlights the least, and the mid-tones proportionally in between. After rinsing, the print is fixed in a bath of sodium thiosulfate and then soaked in water, which causes the gelatin to absorb water in inverse proportion to the amount of hardening. The highlights absorb the most water and swell the most, the shadows the least, creating an image in low relief. The still-damp print is then placed on a glass plate and inked, by hand, with a special brush. Because oil and water repel each other, the oil-based ink (usually lithographic ink) will adhere to the harder, darker areas while being repelled by the lighter, more swollen areas. In a labor-intensive process, the ink is built up in several layers, allowing the photographer to control the distribution of darks, lights, and mid-tones. After drying, the appearance of the print can be further manipulated by selectively applying more ink or by softening or rubbing the surface.

The name bromoil refers to the combination of a bromide print with the oil process, which is similar to the bromoil process but exposes the negative onto gelatin-coated paper sensitized with a dichromate rather than onto a bromide print. Because dichromated gelatin exposes too slowly via an enlarger, oil prints were always contact printed whereas bromoil prints could be made by enlargement.

A bromoil transfer print is produced by using the bromoil print as a matrix to transfer the image to another sheet of paper. The inked matrix and the paper, both dampened, are placed in contact and sandwiched by blotting paper in a special roller press or an etching press and run through several times until the ink is fully transferred to the paper. A bromoil transfer print therefore does not contain any silver or chromate salts, but is rather an ink print on paper.

Dates of Major Use:
1907–1930s

Type: positive print

Inventor:
C. Welbourne Piper
(bromoil, 1907),
Fred Judge (bromoil
transfer, 1909)

Heinrich Kühn, *Die Schnitterin (The Reaper)*, 1924, bromoil transfer print

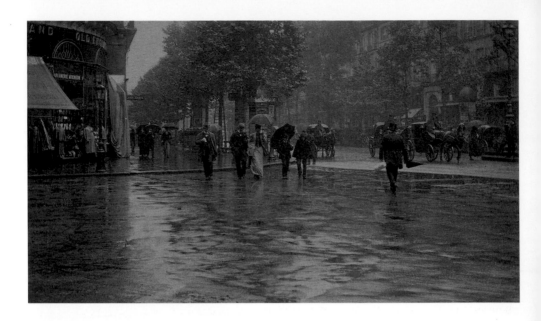

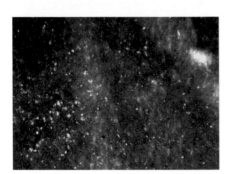
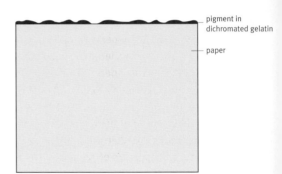

CARBON PRINT

Carbon Print / Patented in 1864, the carbon process is a method of making non-silver, tonally rich, pigment-based prints typically with strong image permanence. By 1868 commercial manufacturers produced carbon print tissue in more than fifty types and thirty colors, making the process applicable to commercial uses, including book illustration and fine art reproduction. Toward the end of the century, it was widely employed by pictorialist photographers who appreciated the range of effects made possible by varying the type of pigment, support, or development process.

A carbon print is made by coating a "backing" paper with a layer of gelatin that has been mixed with pigment. This sheet, known as the carbon tissue, is sensitized in a solution of potassium dichromate, dried, and exposed to light through a negative. The action of light hardens the dichromated gelatin in direct proportion to the amount of light it receives. The exposed carbon tissue is briefly soaked in cold water along with a second (receiving) sheet of paper. Both are removed, and they are squeegeed together so that the selectively hardened tissue is transferred from its original support onto the receiving paper. This "sandwich" is then immersed in warm water. The backing paper is carefully peeled off and the unexposed gelatin washed away, leaving a relief image in hardened, pigmented gelatin on the paper. This single-transfer carbon process produces a laterally reversed image: to correct the reversal, the exposed carbon tissue is transferred to a temporary support (often metal, glass, film, or a smooth, waxed paper), which is then used to transfer the image yet again onto another receiving sheet. In both cases, the final print consists of pigment particles suspended in a layer of gelatin on a paper support.

In 1878, Frédéric Artigue developed a carbon tissue that could be exposed to light and processed without intermediary transfer (direct carbon). Photographers placed the carbon tissue in warm water and washed away unexposed gelatin with the aid of a mild abrasive (usually fine sawdust) to create the image. Artigue and his son Victor, as well as Théodore-Henri Fresson, made further improvements to the carbon tissue process.

While carbon black was the first pigment used (giving the process its name), manufacturers produced a wide variety of colors. Sepia brown and blue-black were common. A shallow relief is often visible on the surface of the print, and the shadow portions usually exhibit some gloss. Carbon prints are not generally susceptible to fading from light exposure; indeed, some carbon prints bear the stamp "Permanent" on their mounts.

CARBON PRINT

Dates of Major Use:
1870s–1900s

Type: positive print

Inventor: Joseph Swan (1855)

Variant Names/ Related Processes: autotype, direct carbon print, Fresson print, pigment print

———

Alfred Stieglitz, *A Wet Day on the Boulevard, Paris*, 1894, carbon print

———

Magnification shows the slight relief of the pigmented gelatin image as well as paper fibers in the highlights, where the gelatin is thinnest.

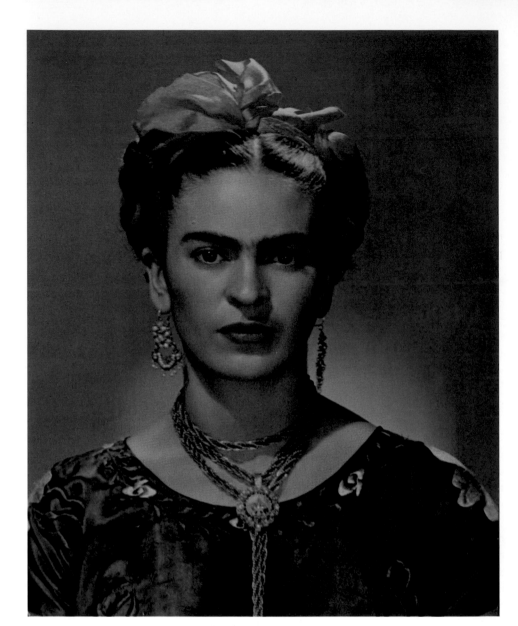

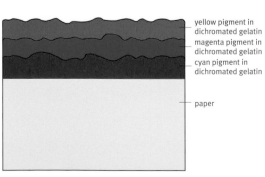

yellow pigment in
dichromated gelatin

magenta pigment in
dichromated gelatin

cyan pigment in
dichromated gelatin

paper

CARBRO PRINT

Carbro Print / Introduced in 1905, carbro was an early color process primarily used for proofing color reproductions in advertising and magazines, though some artists used it to make color prints. Its characteristics include exceptional image permanence and rich, highly saturated color. Like the carbon print process, it utilizes pigmented sheets of dichromated gelatin. However, the dichromated gelatin does not harden by the action of light, as in the carbon process, but through direct contact with a bromide print (a type of gelatin silver print). Hence the name carbro comes from joining the words *carbon* and *bromide*.

A set of three separation negatives is required to make a carbro print. Each negative makes a bromide print, then each print is placed in direct contact with a corresponding carbon tissue, pigmented cyan, magenta, or yellow. The carbon tissue chemically reacts with the bromide print, causing the gelatin in the carbon tissue to harden in direct proportion to the density of the silver in the print. During this reaction the silver in the bromide print is bleached. Each carbon tissue is separated from its print and washed to remove the unhardened gelatin. The tissues are assembled on a temporary support in exact register to create a full-color image and then transferred to a final support to dry. The bromide prints can be redeveloped and reused.

Carbro prints are made from pigments (rather than dyes) suspended in gelatin, which gives them their distinguishing color and also adds to their color stability. They are identifiable not only by their color but also by the telltale signs of their assembly. Because the final print is made up of three superimposed pigmented gelatin tissues, often the individual layers can be detected at the edge of the print as lines of cyan, magenta, or yellow. If the registration of the three images is off even slightly, it will be noticeable in the print. The thickness of the gelatin also gives the prints a slight relief, which can be seen most distinctly at the transition between a shadow and a highlight (the shadow will have thick layers of gelatin while the highlight will have very little gelatin). The complex process was displaced in the 1940s, when the advertising industry began to use the new dye imbibition print process.

CARBRO PRINT

Dates of Major Use:
1905–1940s

Type: positive print, subtractive color

Inventor: Thomas Manly (1905)

Variant Names/ Related Processes: Autotype Trichrome Carbro, Raydex, tri-color carbro, Vivex

———

Nickolas Muray, *Frida Kahlo*, c. 1938, carbro print

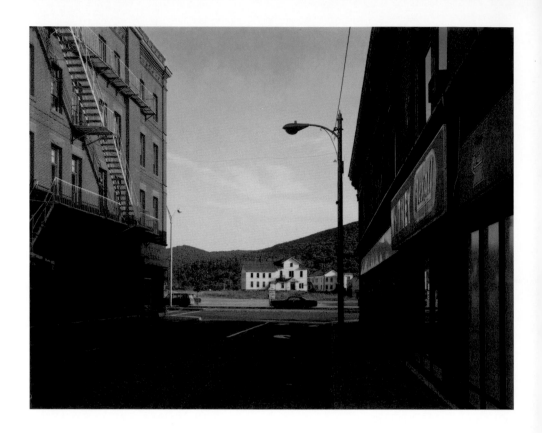

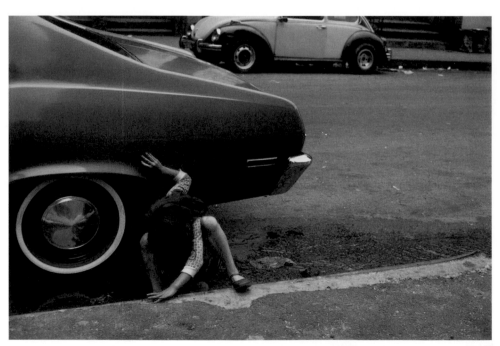

Chromogenic Color / The nearly one-hundred-year-long quest for a commercially viable and reproducible color photographic process ended in the 1930s with the introduction of chromogenic materials, first in the form of transparency film and then in the 1940s as chromogenic negative film and printing papers. This subtractive color process was the most common color photographic process of the twentieth century. Chromogenic color materials consist of dyes suspended in layers of gelatin, yielding realistic hues with a good tonal range and a sense of translucency. Commercial and amateur photographers were the first to adopt chromogenic materials: few artists used chromogenic materials prior to the 1970s, preferring the more labor-intensive **carbro print** and **dye imbibition print** processes because the prints were more stable.

Chromogenic color materials are composed of three **gelatin silver** emulsion layers sensitive to red, green, or blue light, with color couplers (color-forming chemicals) suspended in each layer on either a film or paper support. During development of the silver images, the color couplers react with the used (oxidized) developer solution to form complementary color dyes of cyan, magenta, and yellow (subtractive color, CMY) in proportion to the amount of silver throughout the image. The silver is then bleached out, leaving only dye (in the form of an Image) and residual, unreacted couplers, which are invisible to the eye.

In the early years the dyes tended to fade quickly in light. In the dark, the residual, unreacted couplers quickly yellowed. This is seen as an overall yellowing in the highlights and white margins of prints. Eventually, improved chromogenic technology dramatically reduced the degree of yellowing and made chromogenic color materials more stable. The chromogenic color process displaced the other available color processes. Artists and amateurs found it easier, more cost effective, and free of the registration problems that occurred in the carbro and dye imbibition processes.

CHROMOGENIC COLOR

Dates of Major Use:
1960s–1990s

Type: positive print, negative, positive transparency, subtractive color

Inventor: Rudolph Fischer (1935)

Variant Names/Related Processes: C-print, dye coupler print, incorporated coupler print

Stephen Shore, *Holden Street, North Adams, Massachusetts, July 13, 1974*, chromogenic color print

Helen Levitt, *New York*, 1980, chromogenic color print

— cyan dye in gelatin

— magenta dye in gelatin

— yellow dye in gelatin

— resin-coated paper

CHROMOGENIC COLOR PRINT

Collodion Negative / One of the most common substances used in the practice of photography during the second half of the nineteenth century, collodion (a viscous liquid made from dissolving gun cotton in ether and alcohol) serves as a successful vehicle for the suspension of silver salts. In 1851, Frederick Scott Archer announced this technique for making negatives on collodion-coated glass. The collodion negative soon superseded the **daguerreotype** as the dominant commercial process and remained the most common form of negative until the introduction of the **gelatin dry plate** in 1871. Widely employed in both art and commercial photography, the collodion negative captured a highly detailed image in a relatively short exposure. When printed on albumen paper, the resulting **albumen print** often displayed a great level of detail with a smooth, glossy finish.

To prepare a negative, the photographer added bromide and iodide salts to the collodion, cleaned the glass plate, and evenly coated it with the salted collodion — a maneuver that required a deft hand if one was to avoid streaks. The plate was sensitized in a silver nitrate bath, placed in a plate holder, and inserted into the camera while still wet (hence the term "wet collodion"). After exposure, the photographer removed the negative from the plate holder, poured developer onto the plate to reveal the latent image, and fixed the image by immersing the plate in a bath of sodium thiosulfate. The plate was washed and, in some cases, immersed in other solutions to intensify the image, dried, and usually given a coating of protective varnish. The negative was then ready to print, usually (though not always) on albumen paper. Similar steps could also produce a collodion positive (see **ambrotype** and **tintype**).

At first, photographers mixed their own collodion, using any of the variations of the collodion chemical formula introduced and implemented during the second half of the nineteenth century. Within a few years, manufacturers began to make it available for sale. The developing solution also varied, usually consisting of either pyrogallic acid or ferrous sulfate mixed with acetic acid. →

Dates of Major Use:
1851–1890

Type: negative

Inventor: Frederick
Scott Archer (1851)

Variant Names/
Related Processes:
collodio-albumen
negative, dry
collodion negative,
glass plate negative,
wet collodion
negative, wet plate
negative

Roger Fenton,
*The Princess Royal
and Princess Alice*,
August 1855, wet
collodion negative

varnish

silver suspended
in collodion

glass

COLLODION NEGATIVE

These variations produced negatives with different tonal ranges, while ferrous sulfate allowed a shorter exposure time than pyrogallic acid.

Characteristic markings on the wet collodion plate include pour lines around the outer edges and bottom corner, where the collodion is thickest, a blocked-out corner made by the photographer's thumb when holding the plate for coating, and marks on corners of the plate where it rested in the plate holder. Areas lacking collodion around the edges, owing to handling, are also often visible. Most prints made from collodion negatives are trimmed around the edges to hide these flaws. Moreover, if any of the preparatory steps were not properly executed, the plate may exhibit lines, streaks, dust spots, or white spots (called pinholes).

Preparing the plate immediately before exposure was both labor intensive and inconvenient, especially for photographers working in the field. In 1855, J. M. Taupenot introduced a method for making dry collodion negatives that could be prepared ahead of exposure. The dry process was similar to the wet one: the photographer poured salted collodion onto the plate, sensitized the plate in a silver nitrate bath, and thoroughly washed it. He then poured a preservative solution (of gelatin, albumen, honey, sugar, syrup, or oxymel) evenly onto the surface. The plate was either allowed to dry or sensitized a second time and then allowed to dry. The prepared plates could be used within several days or months after preparation and did not need to be developed immediately upon exposure. The development process for dry collodion, using pyrogallic acid, also differed from the wet collodion process in that the preservative layer had to be dissolved in water and washed away.

Useful for photographers in the field because it did not require the transport of heavy chemicals or equipment, dry collodion was more convenient but less sensitive than the wet collodion process, required longer exposure times, and provided inconsistent results. It thus never gained the widespread popularity that the wet collodion process enjoyed. The gelatin dry plate negative, introduced in 1871, superseded both wet and dry collodion negatives.

Roger Fenton,
The Princess Royal and Princess Alice,
August 1855,
albumen print from the wet collodion negative on p. 24

As with most negatives, the wet collodion negative is both tonally and laterally reversed. The positive print corrects these reversals.

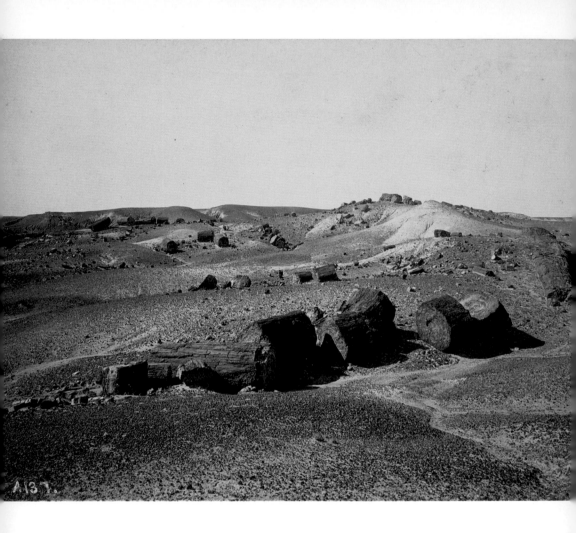

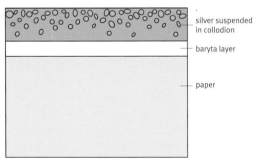

silver suspended
in collodion

baryta layer

paper

COLLODION PRINT

Collodion Print / Although the collodion print process had been discovered in 1864, it was not until the mid-1880s that collodion papers became popular and began to replace **albumen** paper, particularly for commercial portrait photography and cabinet cards. A printing-out paper (P.O.P.), collodion paper was made by applying a coating of a collodion emulsion to a paper with a baryta layer. Two kinds of collodion papers were manufactured: glossy was introduced circa 1885 and popular through about 1905; matte, with starch or other substances added to the collodion emulsion, was introduced in the mid-1890s and remained in use until about 1910. They were first made in Europe under the trade name Aristotype.

Glossy collodion prints exhibit reddish or purple-black image tones similar to those of albumen prints, and, like them, were often toned with gold. Unlike albumen prints, however, they do not tend to yellow in their highlights and are less subject to fading. Matte collodion papers were often toned with gold first and then toned a second time with platinum to endow them with strong image permanence and a neutral image hue.

Collodion prints are particularly prone to image loss owing to surface abrasion, although this is less likely with matte papers than with glossy collodion papers. When examined under fluorescent light, collodion prints sometimes exhibit interference colors, or rainbow iridescence.

Dates of Major Use:
1895–1905
(glossy P.O.P.),
1895–1910
(matte P.O.P.)

Type: print
(printed-out)

Variant Names/
Related Processes:
Aristotype,
collodio-chloride
print, glossy
collodion print,
matte collodion
print

Adam Clark Vroman,
*In the Petrified Forest
(General View, Middle
Park)*, c. 1895–1897,
collodion print

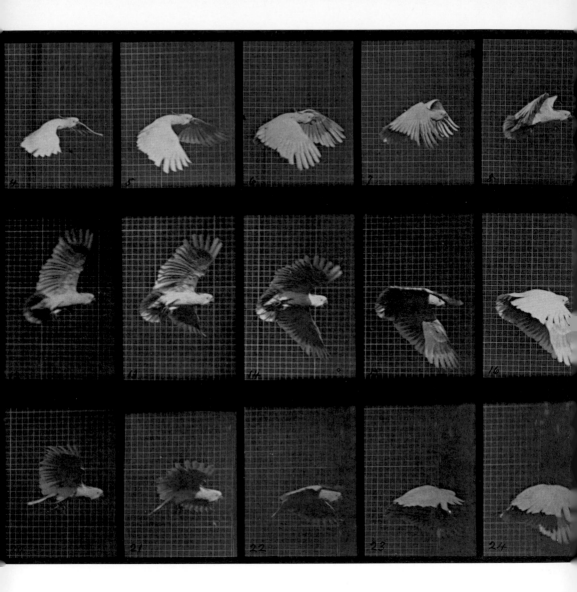

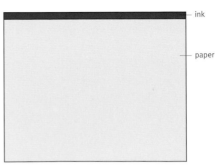

COLLOTYPE

Collotype / The first practical photomechanical process, the collotype was prized for its ability to convey the appearance of continuous tone with a high level of detail. Introduced in 1855 and perfected in the mid-1860s, it was especially popular for high-quality, short-run printing.

To make a collotype, a plate — originally stone but later replaced with glass or metal — was coated with a light-sensitive, dichromated gelatin layer and dried (often in an oven). The plate was then exposed to light through a laterally reversed negative, causing the gelatin to harden selectively in proportion to the amount of exposure it received. The plate was next washed in water, which made the soft, unexposed gelatin swell and buckle. This process created a finely reticulated surface. During the 1860s and 1870s, a number of variations on this process emerged, most involving coating the plate with a substratum, such as albumen, gelatin, or other colloid, and drying it before applying the layer of dichromated gelatin.

When the dampened plate was inked, the shadow portions of the image took up a greater amount of the greasy ink, while the highlights, containing more of the swollen (unhardened) gelatin, took up less ink. The inked plate was then printed in a printing press (often a hand press), usually on smooth paper. The resulting print can be difficult to distinguish from a true photograph, but under magnification the collotype's reticulation pattern is visible.

Although collotypes could be printed in any color of ink, the most typical were black or purplish brown, perhaps chosen to mimic the look of **albumen prints**. In addition, they were sometimes varnished. Formats range from small, postcard size to much larger prints. Unlike **Woodburytypes**, which had to be individually trimmed and hand-mounted in books, collotypes could be printed on paper that was folded and directly bound in.

The advent of the halftone process in the 1890s gradually displaced the dominance of the collotype in photomechanical printing. The collotype process had several drawbacks, including the fragile nature of the plates, which were easily scratched and susceptible to damage from humidity. The gelatin plate's delicacy also limited the number of prints possible to about five thousand.

COLLOTYPE

Dates of Major Use: 1860–1930s

Type: photo-mechanical print

Inventor: Alphonse-Louis Poitevin (1855)

Variant Names/ Related Processes: Albertype, Artotype, autotype, Heliotype, phototype

Eadweard Muybridge, *Cockatoo Flying* (detail), plate 758, from *Animal Locomotion* (University of Pennsylvania, Philadelphia, 1887), collotype

Under magnification, the collotype's slight pattern of reticulation is visible.

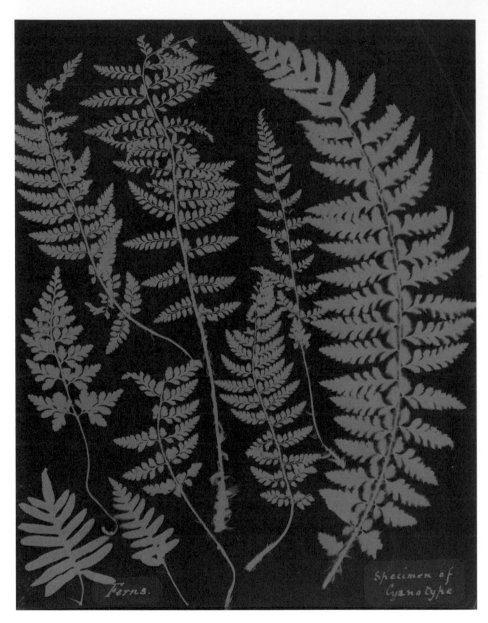

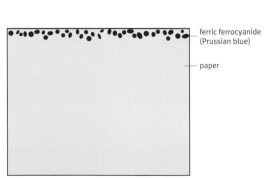

ferric ferrocyanide
(Prussian blue)

paper

CYANOTYPE

Cyanotype / Discovered only a few years after the announcement of the **daguerreotype**, **paper negative**, and **salted paper print**, the cyanotype was introduced in 1842. It was used in the earliest decades of photography to make camera-less photographs, notably of botanical specimens. Because it is one of the simplest and easiest photographic printing processes to master, the cyanotype increased in use around the turn of the nineteenth century among amateur snapshooters. It also found widespread use in architecture and engineering firms as a means of copying drawings and plans, called blueprints, in which the drawing appears in white on a blue ground. Cyanotype paper was commercially produced from 1872.

Cyanotypes are based on the light sensitivity of iron salts rather than silver salts. The cyanotype is a one-layer photographic structure: the image is embedded in the fibers of the support and thus produces a print with a matte surface. To make a cyanotype, the photographer coated paper with a mixture of potassium ferrocyanide and ferric ammonium citrate and hung it to dry. It was then exposed to light in contact with a negative or with an object or drawing laid on top of it. After exposure, the print was washed in water to remove the unexposed chemicals. The resultant chemical mixture created ferric ferrocyanide, also called Prussian blue; as the print dries, it turns bright blue. When toned with different solutions, the cyanotype's color could be changed to gray, reddish brown, black, violet, or green tones. Cyanotypes have a high level of image stability but can fade from exposure to light. However, they can regain some of their image density when stored in the dark.

CYANOTYPE

Dates of Major Use:
1880–1920s

Type: positive print
(printed-out)

Inventor: Sir John
Herschel (1842)

Variant Names/
Related Processes:
blueprint

Anna Atkins, *Ferns,
Specimen of Cyanotype*,
1840s, cyanotype

American, 20th century,
"The Artist," c. 1900–1910,
cyanotype

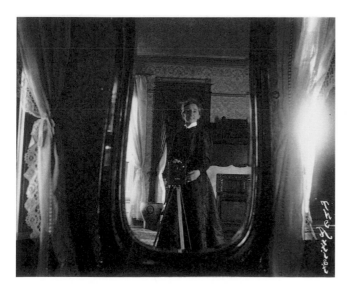

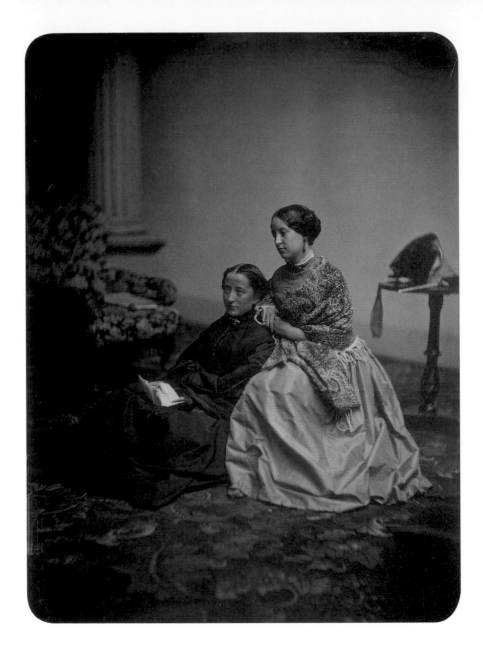

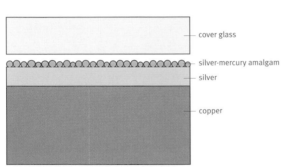

— cover glass

— silver-mercury amalgam
— silver

— copper

DAGUERREOTYPE

Daguerreotype / One of the first viable photographic processes, along with the **paper negative** and salted paper print, Louis-Jacques-Mandé Daguerre's invention caused a sensation when it was introduced in 1839. Once its original lengthy exposure times had been shortened, the daguerreotype, with its highly detailed image, became especially popular for portraiture. Following a heyday in the 1840s and early 1850s, its popularity waned owing to competition from **ambrotypes**, **tintypes**, and prints from collodion negatives, but its use in portrait studios continued into the 1860s, particularly in the United States.

Sometimes called the "mirror with a memory," a daguerreotype is a silver image on a silver-coated copper plate. Careful cleaning and polishing of the plate, which had to be made of high-quality metals, affected the success of the final image. The polished plate was first sensitized through exposure to the vapors of iodine and bromine or chlorine (originally just iodine), producing light-sensitive silver salts on the surface. The photographer placed the plate in the camera and made an exposure. To develop the latent image, the plate was exposed to the fumes of heated mercury, which formed an amalgam with the silver in the areas that had been exposed to light. The plate was fixed by pouring sodium thiosulfate (originally, salt) over it, washed, and dried. Daguerreotypes were usually toned by adding gold chloride to the fixer or by pouring a gold chloride solution on the plate after washing. Portraits were often hand-colored.

Commercially produced plates (primarily from France and the United States) came in a series of standard sizes, ranging from a whole plate of approximately 6½ x 8½ inches to fractions — half, quarter, sixth, ninth, and sixteenth — of whole plates. Manufacturers also produced larger plates, called mammoth plates, and stereoscopic formats. To protect their delicate surfaces, daguerreotypes were matted, placed under a cover glass along with a preserver, edge-sealed with tape, and housed in protective cases.

The daguerreotype's shiny, mirrorlike surface makes the image difficult to see from certain angles. Because it is a direct positive, the image was laterally reversed, although some photographers used reversing prisms or mirrors to correct this problem. Although a high level of precise detail and a subtle tonal range characterize the image, inferior-quality plates, poor processing, or environmental pollutants may result in pitting, stains, and spots. Over time, the silver surface can tarnish, causing a colored film to develop across it. Other problems may result from deterioration of the cover glass, which can obscure the image; for example, droplets known as "weeping glass" can harm the surface of the daguerreotype. Attempts to clean or restore a daguerreotype can also damage the surface.

DAGUERREOTYPE

Dates of Major Use: 1840–1865

Type: direct positive

Inventor: Louis-Jacques-Mandé Daguerre (1839)

Albert Sands Southworth and Josiah Johnson Hawes, *The Letter*, c. 1850, daguerreotype

35

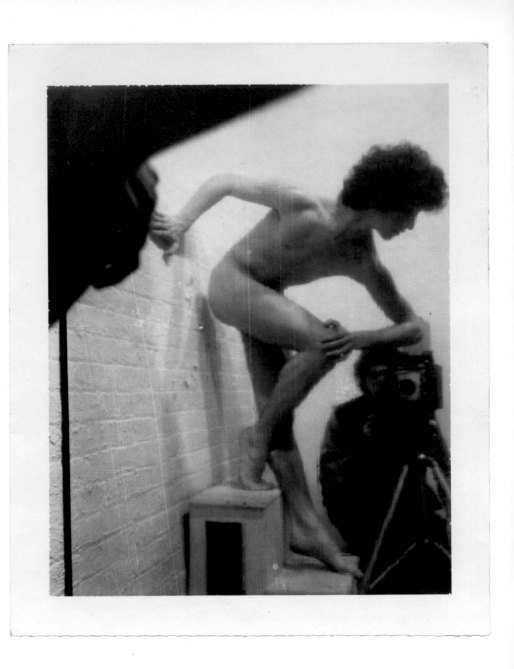

Diffusion Transfer Processes
(Polaroid Instant Photography)

Diffusion Transfer / Introduced in the late 1940s, the diffusion transfer process (commonly known by its trade name, Polaroid) produced instant positive photographic prints, inside the camera, without the need for a darkroom or advanced knowledge of photography. The first commercial Polaroid process required a specially designed camera — the Polaroid Land camera, Model 95 — pre-loaded with a roll of light-sensitive negative film and a roll of positive receiving paper, with attached pods containing processing chemicals. A paper leader fed out of a slot at the bottom of the camera. After exposure, the photographer pulled the leader, advancing the film and paper through a set of heavy steel rollers. This pressure broke the pod, evenly dispersing the processing chemicals, which produced a complex set of chemical reactions. The image was developed in the negative and then transferred, as a positive image, onto the receiving paper. After about one minute, the photographer opened the back of the camera, peeled the positive print from the negative film and leading paper, and discarded the negative. The result was a single, instant, sepia-colored print.

The drawbacks of this first "peel apart" instant film included the high cost of the camera; the manufacturing problems caused by the complex nature of the process; unreliable materials; and the tendency of the delicate prints to fade and scratch. In 1948, Polaroid hired photographer Ansel Adams to test cameras, instant films, and protective coatings and to provide feedback; the result was a much-improved set of products.

Dye Diffusion Transfer (Polacolor) / The first color peel-apart film, Polacolor, was marketed in 1963. Before that, all Polaroid films were black and white. In this dye diffusion transfer process, the film consists of three gelatin silver emulsion layers, each sensitive to one of the three primary additive colors (red, green, or blue). Behind each emulsion layer is a layer containing dye developers of its complementary subtractive color (cyan, magenta, or yellow). During development, dyes corresponding to the unexposed portions of the emulsion layers are transferred to the receiving paper to form a positive colored print, while dyes corresponding to the exposed portions are locked in place on the negative. →

DIFFUSION TRANSFER PROCESSES (POLAROID INSTANT PHOTOGRAPHY)

Dates of Major Use: 1948–2008

Type: positive print, negative, positive transparency, direct positive, black-and-white or subtractive color

Inventor: Edwin H. Land (1947)

Variant Names/ Related Processes: Polaroid

Robert Mapplethorpe, *Self-Portrait (with Dancer)*, 1974, diffusion transfer print

37

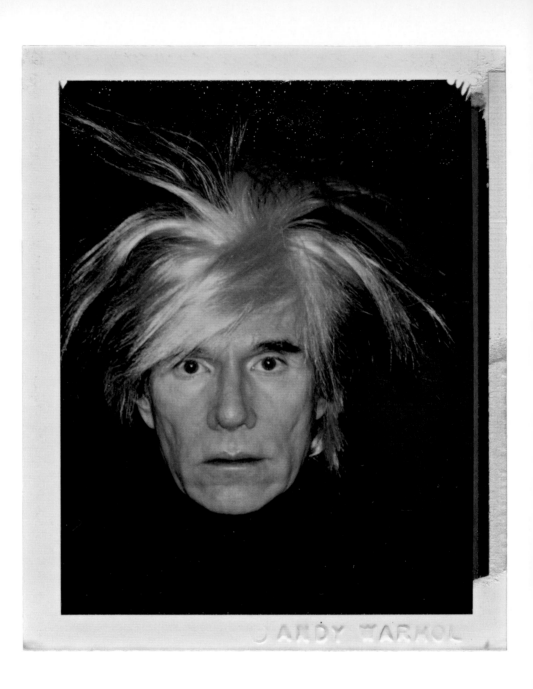

38

Internal Dye Diffusion Transfer (SX-70) / Marketed in 1972 and recognizable by its square image and white border, the internal dye diffusion transfer print, trade name SX-70, is unique in that the negative film, image-receiving layer, and processing chemicals were sealed in a package that remained intact after processing. After exposure in the SX-70 camera, the film was automatically ejected through built-in rollers that broke the chemical pod. The photographer could watch the image slowly appear as the dyes came to the surface. While the SX-70 was marketed to the amateur snapshot photographer, its instantaneity also captivated the imagination of artists: the photographer could manipulate the image by rubbing the print surface as the image developed, altering the formation of the dyes.

Although all of the materials marketed by the Polaroid Corporation are generally referred to simply as "Polaroid," since 1948 the company has manufactured more than one hundred types of instant photographic materials, including instant prints in both black-and-white and color, negatives, and transparencies, all made in a variety of sizes and formats, including roll, pack, and sheet film. Nearly all of these products are based on the same principle as the original Polaroid process: they contain a negative layer or layers, an image-receiving layer, and a pod of processing chemicals; diffusion transfer produces the final image. In 2008, the Polaroid Corporation ceased production of instant film products.

Andy Warhol, *Self-Portrait with Fright Wig*, 1986, dye diffusion transfer print (Polacolor)

Distinctive artifacts of the "peel apart" process are visible on the right side and in the upper corners.

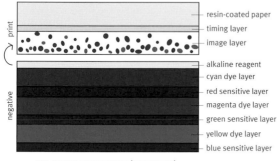

print

negative

resin-coated paper
timing layer
image layer

alkaline reagent
cyan dye layer
red sensitive layer
magenta dye layer
green sensitive layer
yellow dye layer
blue sensitive layer

DYE DIFFUSION TRANSFER (POLACOLOR)

39

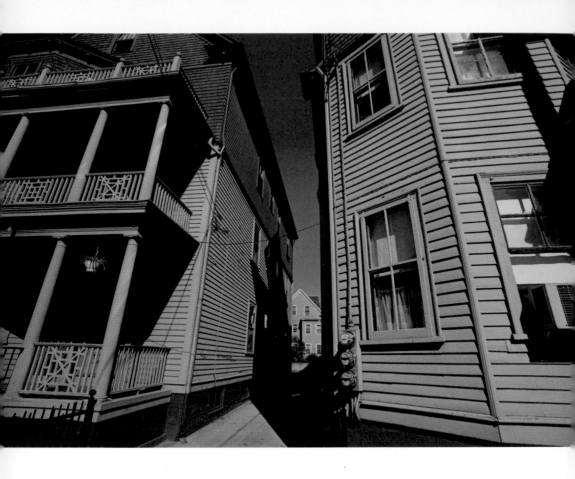

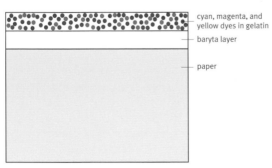

cyan, magenta, and
yellow dyes in gelatin

baryta layer

paper

DYE IMBIBITION PRINT

Dye Imbibition Print (Dye Transfer) / This subtractive color process, based on the principle that gelatin can soak up, release, and transfer dyes to another surface, was first explored in the 1880s and first used to make color motion-picture film (Technicolor) in the 1920s. In 1935, Kodak introduced a dye imbibition print process (Eastman Wash-Off Relief), which was improved and released in 1945 as Dye Transfer, the most successful of the dye imbibition processes. Its rich colors and translucency are the result of using dyes, rather than pigments, in a gelatin binder. Although few artists worked in this process before the 1970s, the advertising and fashion industries of the 1940s and 1950s, as well as journalists in the late 1950s and 1960s, embraced it, despite the substantial cost and the time and skill required to produce high-quality prints.

Dye Transfer prints, the most common form of dye imbibition prints, often begin with a color transparency, from which three separation negatives are made, respectively, through red, green, and blue filters. Each one is printed onto a separate sheet of matrix film (Its size will determine the size of the final print). Gelatin relief images are made with the matrix film by developing with a tanning developer, which leaves a varying thickness of gelatin in proportion to light exposure. The unhardened areas (the highlights) remain relatively soluble in water, while the hardened areas (the shadows) are insoluble, resulting in a positive gelatin relief. Each matrix is then soaked in a complementary subtractive colored dye (cyan, magenta, or yellow); the gelatin absorbs the dye in proportion to the thickness of the gelatin so that the shadows absorb more dye and the highlights absorb less dye. One by one, the matrices are placed in register and rolled onto a gelatin-coated receiving paper, onto which the dye is transferred. The final result is a full-color image.

Compared to the **Autochrome** and **carbro print** processes, dye imbibition offers a fair amount of control to the photographer. The hues and contrast of the image can be adjusted by varying the formulation of the dye baths and re-soaking the matrices to produce a new print, and by applying other darkroom techniques such as masking. Because the gelatin matrices are stable, they can yield new prints years after they are first produced. Dye imbibition prints are also known for their color stability when kept in dark storage.

DYE IMBIBITION PRINT
(DYE TRANSFER)

**Dates of Major Use:
1945–1993**

**Type: positive print,
subtractive color**

**Inventor:
Technicolor (1927),
Kodak (1935, 1945)**

**Variant Names/
Related Processes:
Kodak Dye Transfer**

Harry Callahan,
Providence, 1977, dye
imbibition print

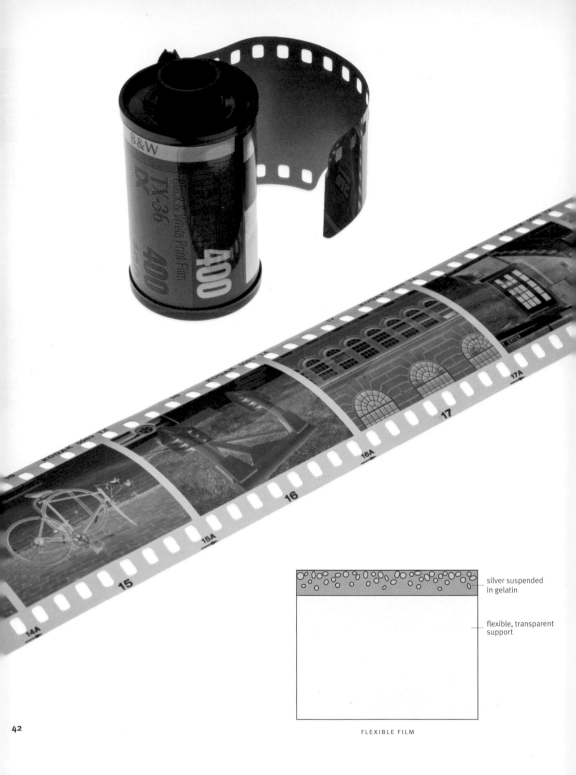

silver suspended
in gelatin

flexible, transparent
support

FLEXIBLE FILM

Flexible Film / Introduced in 1887, this transparent support for black-and-white and color photographic emulsions was the dominant format for negatives throughout the twentieth century. Although largely superseded by digital photography, flexible film remains in use for some still and motion-picture photography. Flexible films, both negative and positive, consist of a gelatin silver emulsion (or emulsions) over a flexible, transparent base (either cellulose nitrate, cellulose acetate, or polyester). While flexible film refers to the support rather than to a photographic process, its use led to the commercial success of the dominant black-and-white and color photographic processes of the twentieth century. Although the film was often small, it could be used for enlargements, especially when combined with **gelatin silver** developing-out papers that could be exposed using artificial light. Eventually standardized to 35 mm, medium, and large-format sizes, black-and-white flexible films are manufactured with both orthochromatic and panchromatic emulsions. Color processes on flexible film include **dye imbibition**, **silver dye bleach**, and **chromogenic color**.

Flexible film answered late nineteenth-century photographers' quest for lighter, flexible alternatives to glass supports and enabled the use of small, lightweight cameras. The invention of a truly transparent, lightweight, flexible film negative depended on the use of celluloid, a nitrocellulose (gun cotton) compound first utilized in 1887 to make sheet film. Cellulose nitrate film negatives were extremely light sensitive, making instantaneous photography possible and, unlike earlier "stripping films" (introduced in 1885 as American Film), did not have to be stripped from its paper support and put onto glass to be printed. Further improvements included panchromatic film emulsions, which became standard for black-and-white still pictures during the 1920s, and the introduction in 1916 of 35 mm film for still cameras.

"Safety film," a cellulose diacetate film, replaced the highly flammable cellulose nitrate film for still photography use, starting in the 1920s. Another safety film, cellulose triacetate, slowly began to replace nitrate film in the 1940s for both motion pictures and still photography. However, acetate films are susceptible to a form of deterioration called "vinegar syndrome," in which the film base degrades and releases acetic acid. In 1955, polyester film was introduced; it remains in use along with triacetate film. Although polyester is a stable film base and a stronger material, it has not completely replaced acetate films because it is more expensive, and it does not unroll or splice as easily as acetate films. It is preferred (though not always used) for some sheet films, micro-films, motion-picture films, and special roll films.

FLEXIBLE FILM

Dates of Major Use: 1887–the present

Type: negative, positive transparency, black and white, or subtractive color

Inventor: Eastman Kodak (1885, American Film), Hannibal Goodwin (1887, cellulose nitrate film base)

Exposed strip of 35 mm Tri-X film, a black-and-white, high-speed film

43

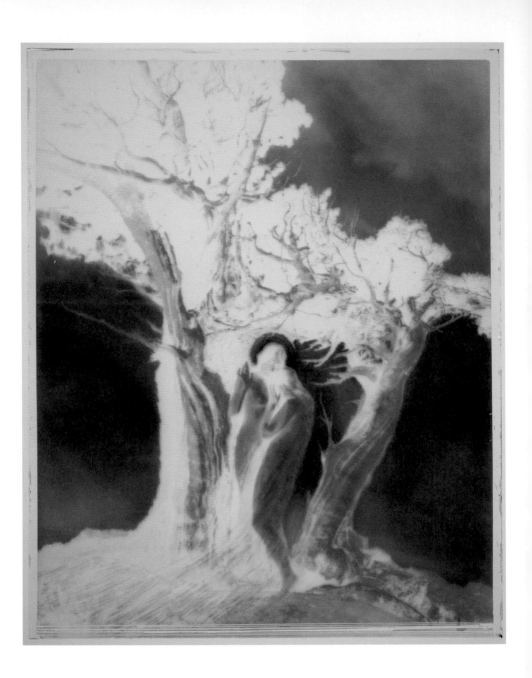

44

Gelatin Dry Plate Negative / Invented in 1871 and improved in 1878, the gelatin dry plate negative freed photographers from the complicated collodion negative process, which required preparing negatives on the spot or setting up portable darkrooms in the field. Landscape photography in particular became far less cumbersome, less toxic, and likely more pleasant. Moreover, the high sensitivity and decreased exposure time of the gelatin dry plate negative — less than one second in good light conditions — enabled nearly instantaneous pictures.

In this negative process, gelatin serves as the binder to suspend light-sensitive silver salts, usually silver bromide and iodide. After preparation, the emulsion is "ripened" by heating it in darkness for hours or days to increase its light sensitivity. It is then cooled into a gelatinous state, and shredded into thin "noodles" that are washed to remove excess chemicals. The gelatin noodles are melted for a second ripening, with added gelatin, hardening agents, and sensitizers. A coating of this hot gelatin emulsion is applied to a clean glass plate, which is dried and kept for later use. After exposure in the camera, a developing solution is poured onto the negative to bring out the latent image. The plate is then washed, fixed, dried, and sometimes varnished to protect the emulsion. Dry plates were complex and labor intensive to prepare by hand, but most photographers purchased commercially manufactured plates, which were ready to use, factory coated, and standardized. Further, they had an excellent shelf life. Developers were also made commercially and needed only to be dissolved in water before use.

Although eventually replaced by lightweight flexible film, its ease and practicality made the gelatin dry plate negative the most popular form of negative in use from 1880 to the turn of the twentieth century.

GELATIN DRY PLATE NEGATIVE

Dates of Major Use: 1880–1900

Type: negative

Inventor: Richard Leach Maddox (1871)

Variant Names/ Related Processes: glass plate negative

Anne W. Brigman, *The Heart of the Storm*, 1906, gelatin dry plate negative

silver suspended in gelatin

glass

GELATIN DRY PLATE NEGATIVE

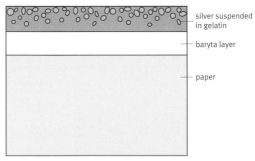

silver suspended in gelatin

baryta layer

paper

GELATIN SILVER PRINT

Gelatin Silver Print / The development of gelatin as a binder for light-sensitive silver salts revolutionized photography and marked the efflorescence of the photographic materials industry. Soon after the introduction of the **gelatin dry plate negative**, two types of gelatin silver papers were being commercially produced: printing-out papers (P.O.P.) and developing-out papers (D.O.P.); the latter would become the most popular print process of the twentieth century. The manufacture of the gelatin silver emulsions for both kinds of papers was similar to that of the gelatin dry plate negative. The papers were machine-coated and pre-sensitized in the factory, obviating the need for photographers to sensitize their papers and opening up the practice of photography to a greater number of amateurs. Factory coating also led to the widespread incorporation of the baryta layer, a layer of barium sulfate (a white, chemically inert pigment beneath the light-sensitive emulsion) that served to coat the paper fibers and brighten the highlights of the image. Printing-out and developing-out papers differ, however, in how the silver image is formed, the chemicals used in processing, the resulting shape and size of the silver particles, and thus the color and image stability of the final print.

Gelatin Silver Chloride Printing-out Papers (P.O.P.) /

These papers bear an emulsion of silver chloride suspended in gelatin, which rests over the baryta layer. Like other printing-out processes, the image is formed by the action of light alone and does not require chemical developing. Therefore, the image is contact printed in sunlight. After exposure, the print is washed in a water bath to remove unexposed silver halides. Most gelatin silver printing-out prints were then toned in gold chloride, giving them a hue ranging from reddish or purple-brown to a neutral gray, similar to that of **albumen** and **collodion prints**. Toning served to increase stability. After toning, the print was fixed with sodium thiosulfate and washed again.

Gelatin silver chloride printing-out papers could be printed using both **collodion negatives** and gelatin dry plate negatives. They also came pre-sensitized (offering an advantage over albumen papers, which had to be sensitized by hand before use) and, after the late 1880s, were manufactured with both glossy and matte surfaces. This combination of attributes encouraged the commercial transition from albumen paper to gelatin paper and contributed to its popularity in commercial studio photography from the late 1880s until the 1910s. The use of these papers was short-lived, however, since gelatin silver developing-out papers, introduced in 1881, ultimately superseded them. →

GELATIN SILVER PRINT

Dates of Major Use: 1885–the present

Type: positive print (printed-out or developed-out)

Inventor: Peter Mawdsley (1873)

Variant Names/ Related Processes: bromide print, chloride print, chloro-bromide print, gelatin silver chloride print

Robert Adams, *Summer Nights #2 (Longmont, Colorado)*, 1983, gelatin silver print, developed-out

Magnification reveals the grain of the silver image in the gelatin binder. The paper fibers of the support are obscured by the baryta layer.

Gelatin Silver Developing-out Papers (D.O.P.) / Developing-
out papers, manufactured with an emulsion that can be made
with varying proportions of silver nitrate with chloride or bromide
solutions, differ from printing-out papers in that the image is
formed through chemical means during development, rather than
printing out in sunlight. To make the print, the paper is briefly
exposed to a negative and then immersed in a developing solution,
which chemically reduces the silver in the latent image into metallic
silver, making the image visible. Once the image is developed,
the print is placed in a dilute acid bath to stop further development
and then fixed in sodium thiosulfate to remove the unexposed
silver halides. The print is thoroughly washed to remove the fixer
and toned with a chemical solution, if desired. In the late nine-
teenth century, gold toner was most often used, but in the twentieth
century, selenium toner became the most common. Depending
on the paper used, the dilution of the formula, and the amount of
time the print was kept in the toning bath, selenium either pre-
served the neutral hues of developed-out gelatin silver prints or
changed them to purple-brown or brown. Sulfide toners, including
sepia toner, were also popular from the 1910s to the 1940s.
In addition to improving image permanence, they imparted a
desirable, warm brown tone. Untoned gelatin silver developed-
out prints are characterized by neutral, gray-black tones.

Gelatin silver bromide developing-out paper, usually referred to
as bromide paper, was one of the earliest gelatin developing-out
papers. First manufactured in 1884 by Eastman Kodak, it produced
a neutral black-and-white image. This very light-sensitive paper
was recommended for printing enlargements. In the 1890s, "gas-
light" papers, generally silver chloride or some combination of
silver bromide and chloride, were introduced. Slower than bromide
papers, gaslight papers enabled an easy, though longer, exposure
of the paper through the negative, which was placed near a high
gas flame. Because gaslight papers did not require a darkroom,
amateur photographers especially appreciated them. →

Eugène Atget, *Magasin,
Avenue des Gobelins*,
1925, gelatin silver print,
printed-out

André Kertész, *Sleeping
Boy*, 1912, gelatin
silver print, developed-
out

The texture of the fiber-based gelatin silver papers changed over time. While the paper stock was made from 100 percent cotton rag in the 1880s, purified wood pulp began to replace rag in the 1920s. Papers were manufactured in a range of textures, from rough to smooth, as well as in a variety of cream and white tones. Papers with a higher surface gloss and a smooth, thicker baryta layer, which increased contrast and brightness, were produced in the twentieth century. Tints were added to the baryta layer, and, starting in the 1950s, optical brightening agents — dyes that make paper and textiles appear whiter and brighter — were added to manufactured photographic papers. The peak of their use was in the early 1960s and after 1980. These papers emit a blue-white glow when viewed under an ultraviolet lamp.

In the late 1960s, resin-coated (R.C.) papers were introduced. Coated with a pigmented polyethylene layer on the emulsion side and a clear polyethylene layer on the opposite side, resin-coated paper prevented the processing solutions from penetrating the paper base. This allowed quick processing and drying, and prevented the prints from curling.

Over time, fiber-based gelatin silver prints can be subject to yellowing, particularly around the edges, and image fading. They are especially prone to silver mirroring in the dark areas, beginning around the edges. Faulty processing can also cause problems. Resin-coated papers can also discolor. They are prone to yellowing, cracking of the surface, and "redox," or reduction-oxidation spots, that appear as small yellow or reddish spots with associated silver mirroring.

László Moholy-Nagy, *Untitled*, c. 1922–1924, gelatin silver print, developed-out

Robert Frank, *Chauffeur/London*, 1951, gelatin silver print, developed-out

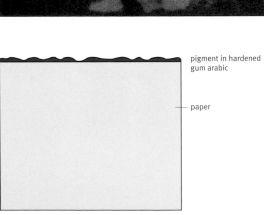

pigment in hardened
gum arabic

paper

GUM DICHROMATE PRINT

Gum Dichromate Print / Made by a versatile and easily manipulated process, gum dichromate prints possess a rich, velvety texture and can be produced in a range of colors, such as carbon black, red ochre, yellow ochre, sienna, or indigo. Traditionally called gum bichromate, this process especially appealed to art photographers at the end of the nineteenth century for its versatility, image permanence, and handcrafted, "painterly" characteristics.

Gum dichromate prints are made by applying dichromate salts (sodium, ammonium, or potassium dichromate) to a sized paper or other support, which is then coated with gum arabic mixed with a pigment (traditionally watercolor pigments, but dry pigments can be used). The paper is then contact printed from a negative. The light causes the gum arabic to harden and become insoluble in proportion to the density of the negative. (The darkest areas of the image will be the most insoluble, the lightest areas the least.) The print is then placed in a bath of water, which washes away the pigment in direct proportion to the solubility of the gum arabic, creating tonal gradations in the image. During this step, the photographer can manipulate the print, by lightening or even removing areas with a brush or other tool — a key factor in the popularity of the process among artists. Finally, the print is dried. These steps are repeated on the same sheet, often several times, to build up the pigment layers and create a lush print. Photographers sometimes used several pigments to vary the look of the final print. The gum dichromate printing process was also combined with other printing processes such as **cyanotype** or **platinum** to produce multiple layers in different materials, further increasing a print's luxurious appearance.

If permanent pigments are used, gum dichromate prints have strong image stability. Additionally, it is a forgiving process in many respects: under- or over-exposure can be corrected, and a darkroom is unnecessary as prints can be made in low light. However, the relative slowness of the emulsion requires contact printing, often multiple times, to achieve the desired tone and depth. Further, gum dichromate prints tend to show less fine detail and tonal gradation than those made by other print processes.

GUM DICHROMATE PRINT

Dates of Major Use:
1890s–1930

Type: positive print

Inventor:
John Pouncy (1858)

**Variant Names/
Related Processes:
gum bichromate
print, gum print,
photo-aquatint**

Gertrude Käsebier,
Mother and Child,
c. 1900, multiple gum
dichromate print

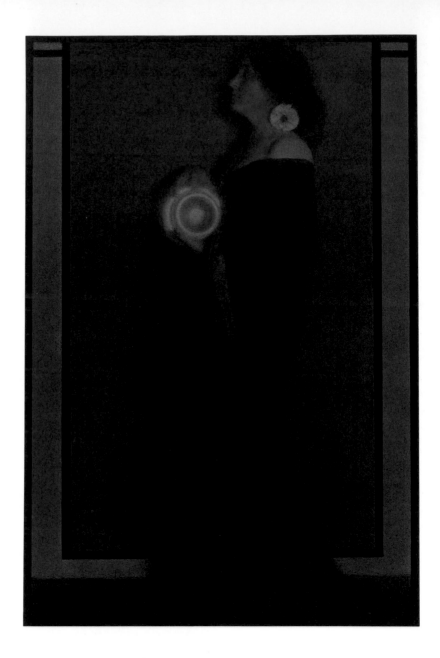

Halftone Print **(Letterpress and Offset)** / A photographic image must be broken up into a pattern to be translated onto a printing plate, as printing presses cannot directly print shades of gray. The halftone process is a photomechanical printing technique by which a photographic image is translated onto the printed page as a pattern of dots of varying sizes. These appear to the naked eye as the continuous tones of a photograph. For letterpress halftone, the dot pattern is transferred to a metal plate, which is then etched and used for relief printing. Letterpress halftone was commonly used to print images in newspapers, magazines, and books until the 1960s, when offset lithography gradually replaced it.

From the 1850s, various methods had been proposed for breaking up the image into a pattern. The halftone process became commercially viable after 1893, with the invention of high-quality, cross-line screens. In this process, which was the basis for halftone printing in the twentieth century, a screen, or grid consisting of a series of intersecting fine, dark lines on a sheet of glass, is placed between the negative and the object to be photographed (often, an original photograph). The screen breaks the image into a series of dots on the negative. The negative is then placed in contact with a metal plate that has been made light sensitive with dichromated gelatin. The plate is exposed to light, which passes through the clear areas of the grid and locally hardens the gelatin in a dot pattern. The plate is washed to remove the soluble gelatin, and the hardened gelatin that remains acts as an acid resist when etched. The finished printing plate now bears a dot pattern in relief. When rolled with ink, the raised dots, or "relief," on the surface of the plate will receive ink, while the etched (light) areas do not take up ink. Shadows are formed by larger dots and the highlights by smaller dots.

The fineness of the halftone screen and the selection of paper determine the resolution of the print. A smoother, glossier paper is often used for halftones with a finer screen, which produces more dots per inch in the image and thus a more finely detailed print. Rougher papers, such as newsprint, can accept fewer dots per inch than the smooth paper used for book illustration; the dot pattern is more easily recognized by the naked eye on the former. →

HALFTONE PRINT
(LETTERPRESS AND
OFFSET)

Dates of Major Use:
1890s–1960s
(letterpress),
1960s–the present
(offset lithography)

Type: photo-
mechanical print

Inventor: Frederic
Ives (1881), George
Meisenbach (1882),
Louis and Max
Levy (1893)

Variant Names/
Related Processes:
dot process,
photo engraving,
screen process

Edward Steichen,
Cover Design, 1906,
halftone print
(duotone)

Magnification of this
duotone reveals
the halftone pattern
of large dots of ink,
in this case black
and brown.

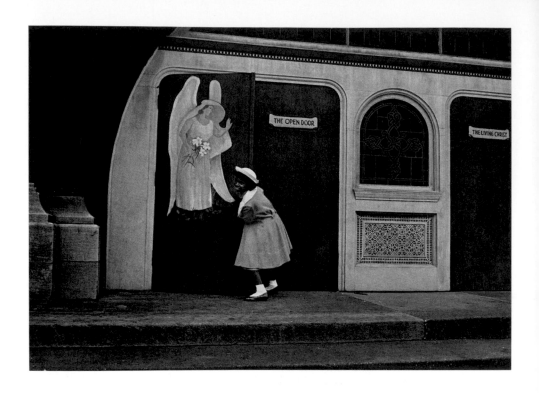

Yasuhiro Ishimoto,
Page 121, *Chicago,
Chicago* (Tokyo, 1969),
halftone print
(offset lithograph)

ink

paper

HALFTONE PRINT

Although usually printed in black ink, halftones were sometimes printed in solid colors or were hand colored. A variation on the halftone process, called duotone, is a two-impression print. Two halftone negatives (one exposed to capture detail in the shadows and the other in the mid-tones and highlights) are used to make two printing plates, one for black ink and one for another color ink (often gray). By printing the color halftone on top of the black-and-white halftone, the mid-tones and highlights of the image are brought out. Because of their wider tonal range, duotones are frequently used for art reproductions and in other publications that aspire to high image quality.

Full-color halftones in magazines and books became common by the 1940s. These were made by photographing the object or original photograph four times through a halftone screen, using color filters (red, green, blue, and yellow), to make four separation negatives. Four separate printing plates were made from the negatives, each inked with its complementary color (cyan, magenta, yellow, and black). Each plate was printed successively on the same sheet to create a full-color halftone print.

In the offset lithographic process, also called photolithography, a photographic negative made through a halftone screen is chemically transferred to a metal plate, which is then attached to a cylinder. The plate is inked and the image is transferred (offset) not to paper but to a second cylinder, which is wrapped in clean rubber (called an offset blanket), and that cylinder in turn transfers the image to the paper. The advantages of offset lithography over letterpress halftone are many: the rubber blanket can transfer a distinct image to the sheet with only light pressure, so that the sheet is not distorted. The rubber protects the plate from abrasion by the rough paper. And because the process includes a second image reversal (from plate to offset blanket), a negative halftone image made directly in the camera can be used. Compared to letter-press halftones, photolithographic plates have higher resolution, or more dots per inch, as well as the ability to be printed faster and on larger sheets.

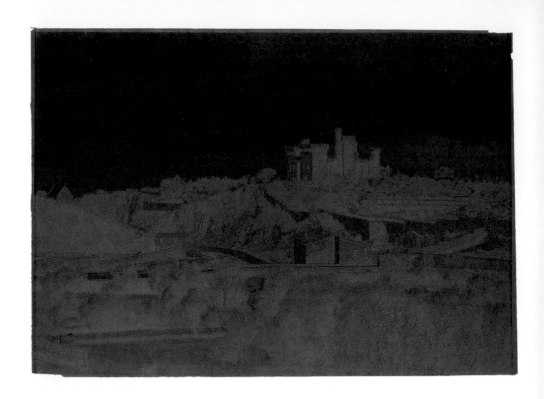

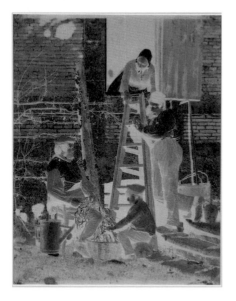

PAPER NEGATIVE

Paper Negative

Paper Negative / The first practical negative process, the paper negative is the basis for the many photographic systems that employ negatives to produce positive prints. It is essentially an improvement upon the even earlier **photogenic drawing** process, with the signal difference that chemical development is introduced after exposure, enabling a shorter exposure time while yielding greater detail.

The paper negative process involves coating a sheet of ordinary writing paper with a solution of silver nitrate, allowing it to dry, and floating the sheet in a bath of potassium iodide; it is coated a second time with a chemical solution of silver nitrate, acetic acid, and gallic acid. The now-sensitized paper is exposed in the camera while damp. Alternately, the sheet could be coated with a single wash of a mixture of potassium iodide and silver nitrate, dried, and kept for later use or placed immediately in the camera for exposure. Some photographers washed the paper after the potassium iodide bath, dried it, and "excited" the negative just prior to exposure with a solution of silver nitrate and acetic or gallic acids. After exposure in the camera, the sheet was developed with chemicals (usually by brushing on a mixture of acetic acid, gallic acid, and silver nitrate) to reveal the image. The paper was then fixed in water or a bath of sodium thiosulfate to stop development. After drying, the negative was often waxed to increase translucency and printing speed.

In the waxed paper negative process, the paper was waxed before it was sensitized, rather than as the last step in making the negative. Sheets could remain viable for months and withstood extremes of temperature, especially heat, making it an ideal process for travel photography. The waxing also yielded a sharper image, prevented the wet sheets from tearing during chemical processing, and could offer faster printing speed; however, the preparation and exposure time in the camera were generally longer.

The photographer could paint or draw on the negative to remove surface blemishes, to create highlights, or to mask part of the negative. With few exceptions, prints made from paper negatives were contact printed and thus the same size as the negative. Although prized for both their convenience (they could be prepared ahead of time and were lightweight) and their ability to produce soft, delicate images, paper negatives never achieved the popularity or commercial success of the **daguerreotype** or, after 1851, the **collodion negative** process. Nevertheless, many photographers, especially amateurs, appreciated the delicacy and artistry of the process and continued to employ it well into the 1860s.

PAPER NEGATIVE

**Dates of Major Use:
1840–1860s**

Type: negative

Inventor: William Henry Fox Talbot (1840)

Variant Names/ Related Processes: calotype, calotype negative, Talbotype, waxed paper negative

Charles Nègre, *Château de Vallambrosa, Cannes*, c. 1852, waxed paper negative

Baron Louis-Adolphe Humbert de Molard, *The Bean Sorters*, c. 1857, paper negative

59

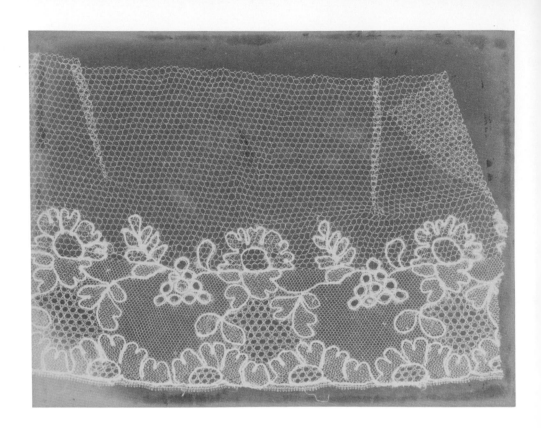

silver

paper

PHOTOGENIC DRAWING

Photogenic Drawing / Photogenic drawing is the name that William Henry Fox Talbot gave to his first camera-less photographic process. Building upon the research of others into the light sensitivity of silver salts, Talbot soaked a sheet of paper in a weak salt solution. After it dried, he coated it with a solution of silver nitrate to sensitize it and then placed objects such as botanical specimens, lace, or other semi-transparent objects on top of the sheet, which he then directly exposed to sunlight. The paper darkened in proportion to the amount of light received. The resulting photogenic drawing was a tonally reversed (negative) image. It could be used as a negative to create a positive print by contact printing it against a second sheet of sensitized paper.

Talbot soon experimented with exposing the sensitized sheets in a camera, although generally these images were less successful and required long exposures (an hour was common) in bright sunlight before an image appeared on the sheet; even then the image often lacked detail. The other drawback to the process was that after exposure, the paper remained light sensitive and would continue to darken if further exposed to light. To counteract this, Talbot washed the prints after exposure in a solution of common salt or one containing either potassium iodide or potassium bromide, which had the effect of stabilizing (but not fixing) the prints; these agents also tinted the prints a range of delicate colors, including blue (chloride stabilized) and yellow (iodide stabilized). Although stabilized, the photogenic drawings were still not fully fixed and remained susceptible to further darkening. In 1839, Sir John Herschel proposed the use of a sodium thiosulfate solution, which completely removed the unexposed silver salts. It rapidly became the standard for fixing the image.

In September 1840, Talbot discovered the phenomenon of the latent image: he briefly exposed a sensitized sheet of paper in the camera, removed it before an image formed, and then chemically developed it. The action of the chemicals revealed the latent negative image. This **paper negative** process, patented by Talbot in 1841, was the first fully viable system of negative-positive photography. Use of the developing agent immediately after exposure greatly reduced exposure time and increased the sensitivity and registration of detail, and it became possible to photograph a greater variety of subjects, including people.

Dates of Major Use:
1835–early 1840s

Type: direct positive, positive print (printed-out), negative

**Inventor:
William Henry Fox Talbot (1835)**

**Variant Names/ Related Processes:
photogram, salted paper print**

William Henry Fox Talbot, *Lace*, 1839–1844, photogenic drawing

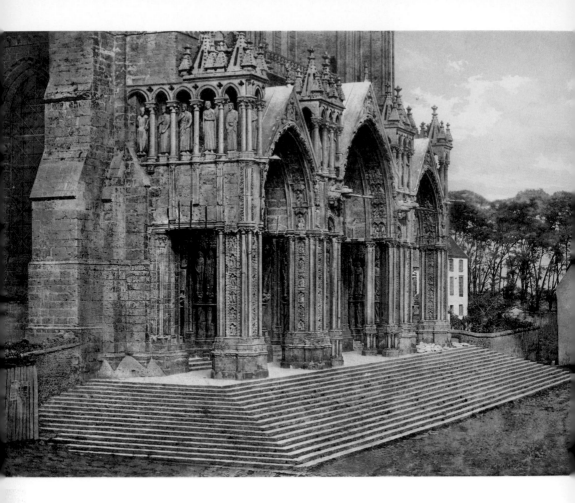

ink

paper

PHOTOGRAVURE

Photogravure / An intaglio process in which a photographic image is chemically etched on a printing plate that is then run through a printing press, photogravure creates high-quality ink prints. While the roots of the process lay in William Henry Fox Talbot's photographic engraving process of 1852, Karel Klíč's improvements in 1879 made the process commercially viable and popular, especially for print editions and book illustration. Artist-photographers from the 1880s through the 1930s especially appreciated photogravure, because they could manipulate the plate to adjust the image, and because it closely approximated the tonal range and appearance of continuous-tone, "true" photographs.

To make a photogravure, a positive transparency of a photographic image is exposed onto a tissue covered with gelatin sensitized with potassium dichromate, which hardens in direct proportion to the amount of light received. This tissue is then transferred face-down onto a metal (usually copper) printing plate that has been dusted with acid-resist grains used in the graphic arts process of aquatint. The grains, in effect, create a screen (like a halftone screen but random and much finer) that breaks up the image. This pattern is the agent by which the photogravure achieves the appearance of continuous tone. The plate and tissue are immersed in warm water and the tissue backing is carefully peeled away. The plate is gently washed to remove the soft, unexposed gelatin and then etched in a series of acid baths. The acid etches the plate at different depths, biting deeply in the areas corresponding to the dark values of the photograph and less deeply in the high-lights. After etching is complete, the gelatin and resin are washed off and the plate is inked, wiped, and printed onto paper, using a printing press. The deeper impressions on the plate, which hold more ink, print as the dark areas of the original photograph, while the shallower impressions print as the mid-tones or highlights.

To the naked eye, a fine photogravure appears to have a smooth, continuous tonal range and, depending on the ink used, can obtain rich, velvety blacks difficult to distinguish from those of **platinum prints**. Under magnification, however, the grain of the resin deposits is visible. →

Dates of Major Use:
1880–1940s
(copperplate
photogravure),
1890s–1960s
(rotogravure)

Type: photo-mechanical print

Inventor: William Henry Fox Talbot (photographic engraving, 1852), Karel Klíč (photo-gravure, 1879)

Variant Names/ Related Processes: engraving, photo-aquatint, photographic engraving, rotogravure, Talbot-Klíč process

Charles Nègre,
Chartres Cathedral,
South Transept,
c. 1854, photogravure

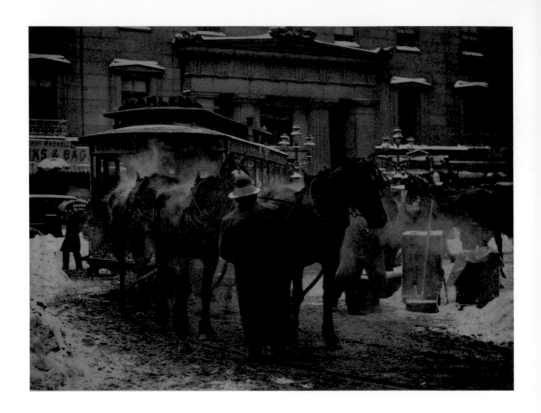

Starting in the 1890s, a finely ruled screen or grid, called a cross-line or gravure screen, similar to the one employed to make halftone prints, replaced the hand-prepared resin screen. Prints made with a cross-line or gravure screen are identifiable by the square shape of the ink cells, laid out in a regular grid on the paper, visible under magnification. Another variation, introduced into high-volume printing, is called rotogravure. It also uses a cross-line or gravure screen, but after exposure the hardened gelatin layer is directly transferred to a cylinder that is then etched, washed, and inked. With a tool called a "doctor blade" attached to the press, the ink is automatically wiped across the plate's surface. By removing ink from the top but not the bottom of the printing cells (the ink-filled depressions of variable thickness in the plate), the doctor blade assures a clean, precise print. The rotogravure process (or roto for short) produces prints more rapidly than a traditional printing press. Its uses include newspapers, books, and other kinds of publications with high print runs, but also fine art books and reproductions. Although more expensive and laborious than letter-press halftone, the beauty and luxuriousness of photogravure and rotogravure, as well as their ability to convey a long tonal range, made them the preferred method for reproducing photographs up to the 1970s.

Alfred Stieglitz,
The Terminal, 1893,
photogravure,
printed in or before
1913

Magnification reveals the grain of the fine screen pattern and the slight relief of the ink on the paper surface.

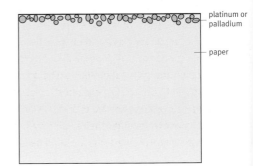

PLATINUM OR PALLADIUM PRINT

Platinum and Palladium Prints / The platinum print process is prized for its rich, long tonal range that includes lush blacks as well as delicate gray mid-tones and for its ability to show fine detail. William Willis's original platinum-based process required a toxic and extremely hot developing bath, but the invention of a printing-out platinum paper and later a "cold development" paper made the process both simple to use and extremely popular by the turn of the twentieth century.

Like the cyanotype, the platinum process is based on the light sensitivity of iron salts. A sheet is sensitized with a solution of salts of iron and platinum, exposed to light through a negative, and chemically developed in a process that removes the iron salts and transforms the platinum salts into platinum metal in the exposed areas. The image, which consists of black or brown platinum metal, is embedded in the uppermost fibers of the paper, resulting in a velvety, matte appearance. Like albumen prints, platinum prints could only be contact printed, but they could be exposed more quickly than silver printing-out papers (although more slowly than silver developing-out papers).

The appearance of a platinum print can be modified in a variety of ways. Although blacks and grays are generally cool, the hue of the print can be controlled by varying the temperature of the developer, by modifying the formulas of the sensitizer or developer, or by applying a chemical toner such as mercury or uranium (which adds warmth to the tone) or lead acetate (which makes the image more neutral in tone). The development process can be retarded by the selective application of glycerin, allowing the photographer to enhance or alter particular areas of the print. Although by the end of the nineteenth century a wide selection of commercially manufactured papers offered a range of textures and tones, some photographers chose to sensitize their papers by hand in order to manipulate the image, suppressing some areas while highlighting others.

Photographers also combined platinum with other processes, especially "gum over platinum," in which a gum dichromate print is made over a finished platinum print to create a rich, multilayered, luminous print. Platinum prints are amenable to secondary processing: the image is embedded in the paper fibers and chemically stable, and it is thus unaffected by subsequent processing. Popular from the late 1880s, platinum became prohibitively costly during World War I, when the United States military required the metal for the production of explosives. →

PLATINUM AND
PALLADIUM PRINTS

**Dates of Major Use:
1880–1930s**

**Type: positive
print (printed-out
or developed-out)**

**Inventor: William
Willis (1873)**

**Variant Names/
Related Processes:
kallitype, palladio-
type, platinotype,
Satista print**

Edward Weston,
The Breast (The Source),
1921, palladium print

Magnification shows the
paper fibers and matte
surface characteristic of
the single-layer process.

Palladium prints, offered as an alternative in 1916, are made by
the same process, but palladium salts are substituted for or com-
bined with platinum salts to sensitize the paper. Palladium prints
are generally warmer in tone with even richer blacks, although
manufacturers offered a "cool black" palladium paper. Palladium
prints have a wide tonal range, and the hue can be controlled in
the same way as that used for platinum prints. Palladium prints
tend to solarize (partially reverse the tones) during printing
and usually require a higher-contrast negative.

The kallitype, a silver-iron process, is another relative of the platinum
print. Made in the same manner as platinum prints but substituting
silver for platinum salts, the kallitype is a less expensive alternative.
It offers a wide range of tones, including black, blue-black, yellow,
and brown; however, the prints are less stable than platinum prints.
Another variant, which never achieved widespread popularity, is
the Satista print, a combination silver-platinum process that uses a
commercially available paper.

Although manufacturers ceased production of platinum and palladium papers by the 1930s, platinum printing experienced a renewal in the late 1960s, when artists began to prepare platinum papers by hand. Although platinum prints have historically been considered more stable than silver-based ones, platinum is a catalyst that can form acids in paper as a result of coming into contact with atmospheric pollutants.

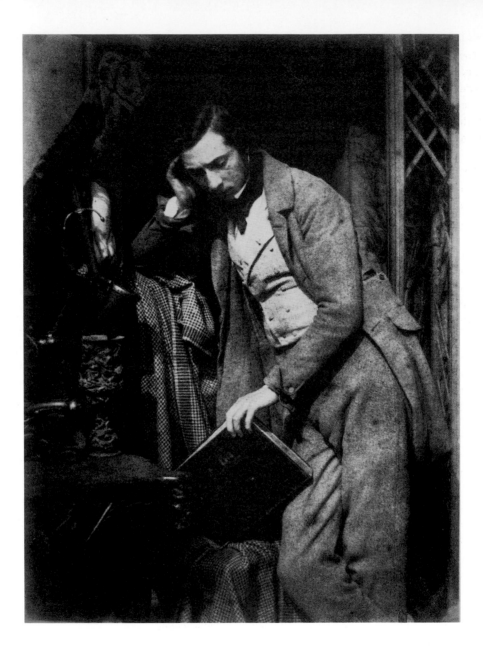

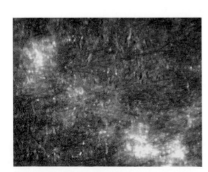

SALTED PAPER PRINT

Salted Paper Print / In use primarily from 1839 through the 1860s, the salted paper print was among the first positive print processes. Characterized by a matte surface, soft appearance, and diffused details, the process found appreciation among art and amateur photographers who associated the glossier, more detailed surfaces of the **daguerreotype** and the **albumen print** with commercial photography.

The process begins with a sheet of ordinary writing paper coated with a solution of sodium chloride (common salt). After the paper dries it can be kept indefinitely, but before use it must be recoated, with a solution of silver nitrate, to make it light sensitive. When placed in contact with the negative in a printing frame and exposed to sunlight, a metallic silver image appears, or prints out, on the paper. The image is tonally reversed from the negative. The print is then washed, fixed, and dried. Some photographers exposed the paper to ammonia fumes before printing to increase printing speed and tonal contrast.

Although salted paper prints are usually printed out in the sun, they are occasionally developed out chemically in a darkroom. Developed-out prints usually have a more neutral or cool tonal range than printed-out prints, characterized by soft, warm browns and purples. Although developing-out the prints was faster, most photographers preferred the hues of printed-out prints. Most salted paper prints were also toned with gold chloride, which improved permanence and changed the hue from a reddish color to a more desirable soft brown or purple, before fixing. The final appearance of the print depends on many other factors, including the choice of paper. Plain salted paper with little or no sizing produces a matte surface and a print with lower maximum density than prints made on sized paper. Some photographers added albumen, tapioca starch, arrowroot starch, or other sizing to the paper. By the 1850s the availability of waxed, unwaxed, salted, and albumenized papers offered an array of possibilities: a smoother surface that better captured delicate details and gave a wider tonal range, and varying glosses. Nevertheless, the salted paper print never achieved the popularity of either the daguerreotype or the albumen print. It was rarely used by the end of the 1860s.

SALTED PAPER PRINT

Dates of Major Use:
1840–1860s

Type: positive
print (printed-out
or developed-out)

Inventor: William
Henry Fox Talbot

Variant Names/
Related Processes:
calotype, salt
print, Talbotype

David Octavius Hill
and Robert Adamson,
James Drummond,
c. 1844, salted paper
print

Magnification shows
the paper fibers and
matte surface characteristic of the single-layer
process.

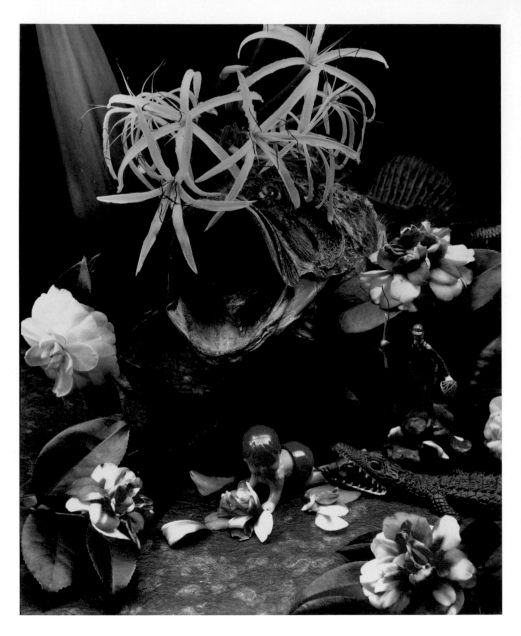

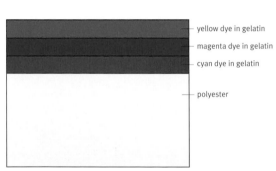

yellow dye in gelatin

magenta dye in gelatin

cyan dye in gelatin

polyester

SILVER DYE BLEACH PRINT

Silver Dye Bleach Print / Unlike other subtractive color processes such as **dye imbibition**, silver dye bleach is a direct positive process that does not require an intermediary negative. Instead, the exposure is made through a positive transparency such as a 35 mm slide directly onto a plastic support coated with three emulsion layers. Each layer has been sensitized to one of the primary additive colors (red, green, or blue) of light, and each contains a complementary subtractive color dye (cyan, magenta, or yellow). The process gets its name from the fact that during development, the silver and the unnecessary dyes are selectively bleached away to create a final, full-color positive print.

Various silver dye bleach processes were introduced in the 1930s for both still and motion pictures, but the first truly successful silver dye bleach print material, known by its trade name Cibachrome, was not introduced until 1963. Although artists soon began making silver dye bleach prints after the introduction of Cibachrome, they tended to use the process less often than, for example, **chromogenic color** prints, because the materials were more expensive and the printing more time-consuming and complex. Because silver dye bleach prints are printed on a plastic rather than a paper support, they usually have a glossy, opalescent surface. And because they are direct positives made from a transparency, they have a black rather than a white border. They are further identifiable by their high contrast and richly saturated colors. In comparison with chromogenic prints, silver dye bleach prints are more chemically stable and tend to have brighter highlights.

SILVER DYE BLEACH
PRINT

Dates of Major Use:
1963–the present

Type: direct positive, subtractive color

Inventor: Bela
Gaspar (1930),
CIBA (1963)

**Variant Names/
Related Processes:**
Cibachrome,
dye destruction
print, Gasparcolor,
Ilfochrome

Robert Fichter, *Look
Out Baby*, c. 1982,
silver dye bleach print

Gordon Matta-Clark,
Conical Intersect, 1975,
silver dye bleach print

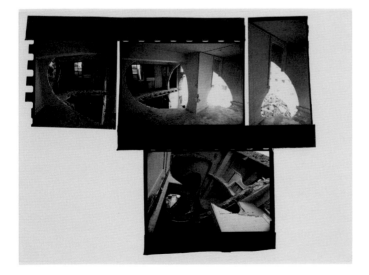

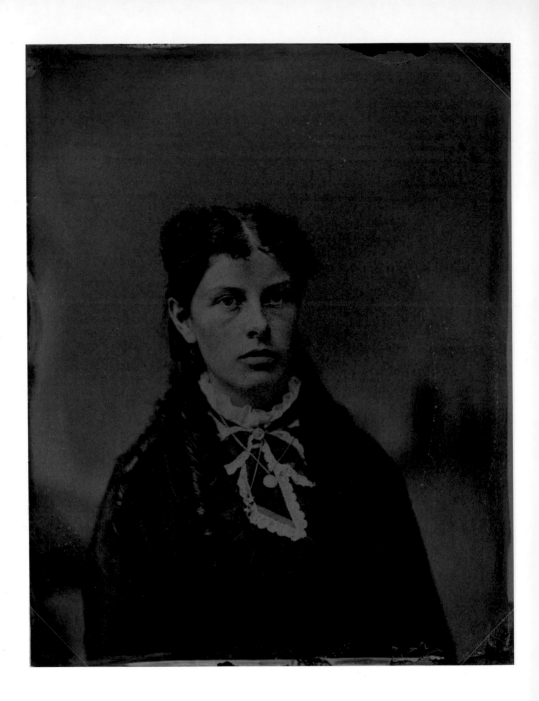

Tintype / A direct positive, the tintype was used primarily for commercial portrait photography in the United States and, to a lesser extent, Great Britain. Printed on a metal support less prone to breaking than glass, tintypes could be cut up and placed in jewelry such as lockets or pins, mounted in albums, or sent to loved ones through the mail. After the introduction of the *carte-de-visite* portrait in the late 1850s, tintypes were also mounted on small cards. Their popularity decreased after the 1860s, but tintypes survived into the first decades of the twentieth century as holiday novelties.

Like the **ambrotype**, the tintype's silver Image is formed as a negative but appears as a positive when viewed against the dark background of its support — a sheet of iron (not tin) coated with black or brown-black lacquer or enamel. To make a tintype, potassium iodide and bromide are added to collodion, which is then evenly poured onto the black "japanned" surface of the iron support. The sheet is then sensitized to light in a bath of silver nitrate, placed in a plate holder, and exposed in the camera. The sheet is developed, fixed, washed, dried, given a protective coating of varnish, and sometimes hand-colored.

Because tintypes can be viewed only from one side, the tintype image is always laterally reversed, unless the photographer optically corrected it with a reversing mirror or prism during exposure. Inexpensive and not always made to the highest photographic standards, the creamy white or gray-silver image on a black support can appear flat, with low contrast.

Like ambrotypes, tintypes came in a range of sheet sizes and were sometimes made with a multiplying camera. To hide their messy edges, they were housed in cases with a cover glass, a mat, and a preserver or, more commonly, placed in frames or paper mats. A variation on the tintype, the pannotype is printed on other dark-colored surfaces such as leather, wood, or cloth.

Dates of Major Use:
1855–1860s

Type: direct positive

Inventor:
Adolphe-Alexandre Martin (1853), Hamilton A. Smith (1856)

Variant Names/ Related Processes: ferrotype, melainotype, pannotype

J. G. Ellinwood, *Portrait of a Woman*, c. 1870, tintype, hand-colored

The faint imprint left by an oval mat is visible on the surface of this tintype.

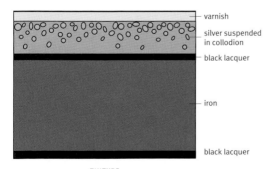

varnish

silver suspended in collodion

black lacquer

iron

black lacquer

TINTYPE

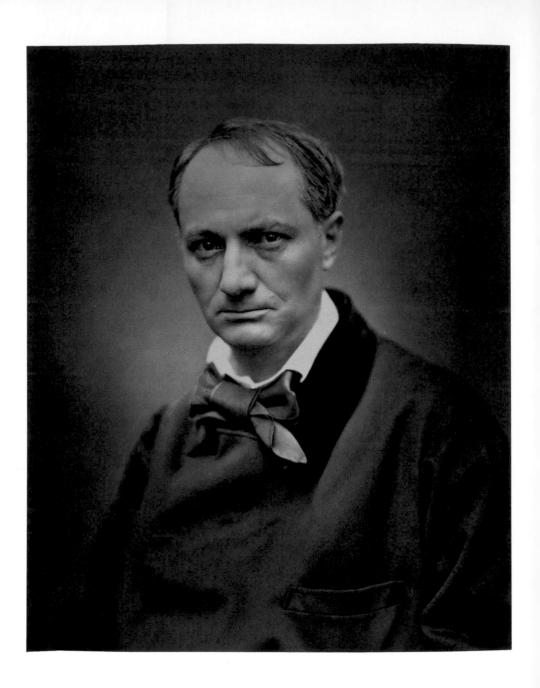

Woodburytype

Woodburytype / A labor-intensive, photomechanical method of producing pigment-based prints, the Woodburytype is prized for its continuous-tone image and resistance to fading. Its primary use was for fine book illustrations from about 1870 to 1895.

Along with the **bromoil**, **collotype**, and **photogravure** processes, the Woodburytype process relies on the hardening action of light upon dichromated gelatin. Three steps are involved: making a gelatin matrix from a photographic negative, making a relief metal plate from the matrix, and printing the plate in a printing press. A single gelatin matrix could be used to make up to six printing plates, enabling simultaneous production of multiple prints.

The first step, the creation of a gelatin matrix, is similar to that followed in the **carbon** process. First, a sheet or plate is covered with a solution of dichromated gelatin and dried (usually in a dessiccating box). This sheet is exposed through a negative to light, which hardens the exposed gelatin, rendering it insoluble. The plate is then washed to remove the unexposed gelatin. The result is a relief image, or "matrix," made of hardened gelatin in varying thicknesses that correspond to the density of the negative. This dimensional matrix is then placed against a sheet made of lead in a hydraulic press, and an intaglio impression is created in the lead sheet. A mixture of liquefied gelatin and pigment is poured into the lead "mold," which is placed in a specially devised press, similar to a book press. Under heavy pressure, the pigmented gelatin is pressed into a sheet of sized and varnished paper. The prints are usually then hardened in a chemical bath before they are washed and dried. →

WOODBURYTYPE

Dates of Major Use: 1870–1895

Type: photo-mechanical print

Inventor: Walter B. Woodbury

Variant Names/ Related Processes: photoglyptie, relief-printing, Stannotype, Woodbury Process, Woodburygravure

Etienne Carjat, *Charles Baudelaire*, 1861, Woodburytype, printed in 1877

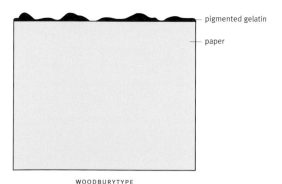

pigmented gelatin

paper

WOODBURYTYPE

Woodburytypes are generally trimmed and mounted on paper, card stock, or even glass, or inserted (tipped in) on a book page, but unlike letterpress halftone prints, they cannot be printed directly onto pages with text. The Woodburygravure is a finished Woodburytype that has been cropped from its original support while still wet and attached to a second piece of paper, which can then be bound directly into a book, avoiding some of the hand work of tipping-in. The Stannotype, another variant of the Woodburytype process and oriented toward the amateur user, did not require a metal plate. Instead, the gelatin relief matrix was simply covered with a thin sheet of tin, coated with the gelatin-pigment mixture, and placed directly in the press.

The only photomechanical method that achieves the continuous tones of a true photograph without any visible grain on the surface of the print, the Woodburytype could be printed in any color but was most often made to mimic the brown tones of an albumen print. As is true of carbon prints, a subtle relief is often visible on the surface of Woodburytypes. But unlike carbon or collotype prints, which can be any size, Woodburytypes tend to be 8 x 10 inches or smaller, since the size is limited by the capacity of the hydraulic press. Woodburytypes are difficult to distinguish from carbon prints, and they were often published with an identifying inscription naming the process or sometimes simply with the name of the printing firm. They are stable and do not fade because they are pigment based. However, the gelatin tends to crack in the areas where it is thicker (the shadow portions of the image), leaving visible cracks on the surface of the print.

Glossary

Photographic processes that appear in colored type are treated in full in the main body of the text.

A

Accelerator: A chemical added to increase the speed of light-sensitive materials or, during development, to shorten the duration by bringing out the image more quickly.

Acetic acid: A clear fluid that is often diluted with water and used as a stop bath in order to halt chemical development of gelatin silver prints and negatives, and as a restrainer for the development of **paper negatives** and collodion negatives. It is also used in combination with cellulose to make cellulose acetate film base. When the film degrades, it releases acetic acid, giving off a strong vinegar smell.

Additive color: The principles through which all colors are achieved by mixing together, or adding, the primary colors of light: red, green, and blue. Mixing all three colors in equal proportions results in white light. Additive color photography systems create color images by projecting three overlaid primary colored images, or by photographing and viewing an image through a screen of small dots or lines of primary colors. *See* **Autochrome**.

Albumen: A protein found in egg whites that is used to suspend light-sensitive material on glass (for negatives) or on paper (for positive prints).

Arrowroot: A starch used to size hand-coated sensitized papers. It is also used as a binder for silver halides in place of albumen.

B

Baryta: A coating of opaque white barium sulfate in gelatin, applied to many photographic printing papers manufactured since the 1880s. The baryta layer supports the sensitized emulsion layer and serves as a barrier between it and the paper support. The baryta layer generally increases the whiteness of the paper and can be modified to produce different surface textures, matte or glossy.

Bichromated colloid:
See Dichromated colloid.

Binder: A transparent layer in photographic materials in which the image-bearing metals or pigments are suspended. Common binders include albumen, collodion, and gelatin.

Bleaching: Bleaching occurs when a silver-based print is treated with a chemical oxidizing solution that reduces the metallic silver to a silver halide. The silver halide can then be dissolved and washed away or dyed.

Bromide paper (print):
See **Gelatin Silver Print**.

Burnished: A popular technique used during the nineteenth century to give finished prints a smooth, glossy surface. Most commercial **albumen prints** made after 1870 were put through a burnishing and rolling machine.

C

Cabinet card: A popular photographic format from the late 1860s through the late nineteenth century, typically used for portraiture, in which **albumen**, **collodion**, or **gelatin silver** printed-out prints are mounted to a thick card measuring $6^{1}/_{2} \times 4^{1}/_{4}$ inches. The mounts usually had decorative designs and the photographer's studio information.

Camera: A light-tight chamber with an opening (or aperture), usually fitted with a lens and shutter, through which an image is projected and recorded on a light-sensitive surface, such as photographic film, glass, or paper. The word camera derives from *camera obscura,* an optical apparatus popularly used as an aid for drawing from the seventeenth through nineteenth centuries.

Carte-de-visite: Introduced by André Adolphe Eugène Disdéri in 1854, the *carte-de-visite* was a popular photographic format in the mid-nineteenth century, until the cabinet card superseded it. Primarily used for portraiture, it consisted of a small print (often **albumen**, but it was also made by photomechanical processes) mounted to a thick card measuring $4 \times 2^{1}/_{2}$ inches. The card mount usually bears the photographer's studio information. Its name derives from its small size, similar to that of the visiting card.

Cellulose acetate film: Celluloid (cellulose treated with nitric acid) treated with acetic acid, which produces a clear, flexible plastic used as a flexible film base. *See* **Flexible Film.**

Cellulose nitrate: The earliest transparent flexible film, made by treating cellulose with nitric acid. *See* **Flexible Film.**

Collodion: Cellulose (usually from cotton) treated in nitric and sulfuric acid and dissolved in a mixture of alcohol and ether. In photography, it is used as a binder. *See* **Ambrotype**, **Collodion Negative**, **Collodion Print**, **Tintype**.

Colloid: A homogeneous mixture created when one substance is evenly suspended or dispersed in another substance. In photography, colloids are formed when light-sensitive chemicals, metallic particles, or pigments are suspended in substances such as albumen, collodion, gelatin, or gum arabic.

Color coupler: Also called dye couplers, these color-forming chemical compounds form the image in the **chromogenic color** process. When the silver image is developed, the developer reduces the silver halides into metallic silver. The couplers react with the oxidized developer, transforming the couplers into organic color dyes.

Contact print: Created by placing a negative in direct contact with light-sensitive printing material and exposing it to light. The resulting image is the same size as the negative. Most nineteenth-century prints are contact prints.

Cross-line screen: An opaque grid pattern between two clear glass sheets, through which images are photographed to produce a **halftone print**. The cross-line screen is mounted between a continuous-tone image and the lens. The "dots" produced by the cross-line screen are square.

Cyan, Magenta, Yellow (CMY): *See* Subtractive color.

D

Darkroom: A darkened room in which photographers can safely handle light-sensitive material. Initially, the limited sensitivity of photographic materials allowed photographers to work in low, artificial light. With the advent of faster, more light-sensitive emulsions, safelights were introduced.

Development: A process by which a latent image is made visible with the use of a chemical agent that "develops" light-sensitive silver halides, reducing the silver to a metallic silver state. The chemical agent is often referred to as the "developer."

Developing-out: The action of light on light-sensitive materials in which a latent image is formed and then made visible through chemical development. In silver-based processes, the chemical developer reduces the exposed silver halides into metallic silver, forming the image. Developing-out processes can either be contact printed or printed using an enlarger and artificial light. Developing-out differs from printing-out, in which the action of light alone makes the image visible.

Developing-out papers (D.O.P.): Photographic papers that are developed-out. *See* Developing-out.

Diascope: An apparatus for viewing **Autochromes**. The diascope allowed light to shine through an Autochrome plate and reflect the image in a mirror, allowing the viewer to see the image clearly in the reflection.

Dichromated colloid: Also called bichromated colloids, dichromated colloids are made by combining dichromate salts (potassium, ammonium, or sodium dichromate) with a colloid (typically gelatin or gum arabic). When exposed to ultraviolet light, the dichromate is chemically reduced, which hardens the colloid and renders it insoluble. When exposed through a negative, the thinnest portions of the negative (the shadows) harden, and the densest (the highlights) remain soluble. The hardened colloid acts as a binder for pigments, forming the image. Carbon, **gum dichromate**, **carbro**, and many photomechanical processes use dichromated colloids.

Dichromated gelatin: See Dichromated colloid.

Direct positive: A process in which a positive image is obtained without the use of a negative. See Ambrotype, **Daguerreotype**, Silver Dye Bleach Print, **Tintype**.

Dye coupler: See Color coupler.

E

Emulsion: A mixture of light-sensitive silver halides suspended in a binder such as albumen, collodion, or gelatin.

Enlargement: A photographic print that is larger than its negative and usually made by placing a negative in an enlarger. Enlargements came into widespread use with the advent of flexible film and gelatin silver papers in the twentieth century. Before that time, most photographs were contact printed; if a larger print was desired, the photograph was rephotographed using a larger negative. See Gelatin Silver Print.

Enlarger: An apparatus equipped with a magnifying lens used for printing enlargements. A negative is placed in the enlarger and artificial light is projected through it and the magnifying lens onto a light-sensitive material (usually positive printing paper). Enlargers came into widespread use with the advent of flexible film and gelatin silver papers in the twentieth century. However, enlargers called "solar cameras" that used sunlight were in occasional use by the late 1850s. See Gelatin Silver Print.

Exposure: The action of light on light-sensitive materials, varying in time depending upon the light sensitivity of the materials and the strength of the light source, whether sunlight or artificial.

F

Ferrotype: A technique in which a wet **gelatin silver print** is placed in contact with a smooth, shiny surface such as glass or metal. As the print dries, the gelatin takes on the highly glossy luster of that surface. Before the introduction of resin-coated papers, ferrotyping offered an aesthetic alternative to the matte surface of gelatin silver fiber-based prints.

Film: See Flexible Film.

Filter: Transparent piece of glass or plastic placed in front of a camera or enlarger lens. Most filters are colored in order to absorb spectrums of light. Other filters act to alter the image, reduce the light's intensity, or control its reflections on various surfaces.

Fix: To dissolve chemically the unexposed, light-sensitive silver halides that remain in photographic materials after development. In the nineteenth century, sodium thiosulfate (called sodium hyposulfite or "hypo") and potassium cyanide were commonly used to fix photographic images. Gelatin emulsions required a more vigorous fixer of ammonium thiosulfate. After fixing, the dissolved silver halides and fixing solution must also be washed out.

Flexible film formats: Modern flexible films (both negative and positive) are manufactured in a variety of formats. Roll films come in 35 mm and medium formats. The former (measuring 35 mm wide, giving the format its name) is the most popular roll film size and allows 24–36 exposures per roll. Medium-format roll films are either 6 × 6 cm or 6 × 4.5 cm and produce square or rectangular images, respectively. They are made in 120 film format, which allows 12–16 exposures per roll, and 220 film format, which allows 24–32 exposures per roll. Sheet film, or large-format film, comes in a variety of sizes including 4 × 5 in., 5 × 7 in., and 8 x 10 in. In general, larger negatives can produce larger, more detailed prints.

G

Gelatin: A natural protein, called collagen, extracted from cattle hides, bones, and connective tissues and used as a binder and colloid to make gelatin for photographic materials.

Glass plate negative: Glass coated with a binder, such as albumen, collodion, or gelatin, and sensitized. *See* **Albumen Print, Collodion Negative, Gelatin Dry Plate Negative**.

Gum arabic: A substance exuded by the West African *Acacia senegal* tree. It is used as a colloid in the **gum dichromate** process. *See* Dichromated colloid.

H

Halide: A salt formed by combining a halogen (bromine, chlorine, iodine) with an elemental metal (ammonium, cadmium, potassium, sodium) to produce bromide, chloride, or iodide.

Hypo: *See* Sodium thiosulfate.

I

Imbibition: To imbibe or absorb. In the **dye imbibition** process, the gelatin in the matrix film has the ability to imbibe and release dye onto a paper support.

Intaglio: A printmaking technique in which the image or design is incised (either through a ground applied to the plate and then etched with acid, or engraved directly on the plate). The plate is inked and the surface wiped clean; the ink that remains in the incised areas is received by the paper when the plate and paper are run through a press. *See* **Photogravure, Woodburytype**.

Iron salts: The chemical combination of iron with an organic acid (tartaric, citric, or oxalic). These ferrous (or iron) compounds reduce the halides (or salts) of noble metals (platinum, gold, copper, mercury, and silver) to metallic particles in the presence of light energy. The **platinum** process is based on the ability of ferrous compounds to reduce salts of platinum or palladium when exposed to light. In the **cyanotype** process, potassium ferricyanide combined with ferric ammonium citrate forms the pigment ferric ferrocyanide (Prussian blue) when exposed to light.

L

Lantern slide: A positive transparent image on glass, which is viewed by projected light. First manufactured in 1848, they were often hand-colored.

Latent image: An image formed in developing-out photographic materials when light-sensitive silver halides are exposed to light, causing a photochemical reaction: tiny clusters of metallic silver form within the silver halide crystal. These specks of silver create the invisible latent image. During chemical development, the invisible silver atoms are converted to visible metallic silver, forming the invisible image.

M

Mammoth plate: *See* Plate size.

Matrix film: Transparent film with a dichromated gelatin emulsion, which when exposed to light (through a positive transparency) hardens in proportion to the amount of light. It is processed in a developer containing a tanning solution, which further hardens the gelatin. The unexposed, soluble gelatin is washed away, leaving a positive image in relief.

Moiré pattern: A photomechanical reproduction flaw caused by an off-register, layered colored-dot pattern.

Monochrome: A term that describes an image that is composed of a single color.

Mount: Paper, card stock, or paper board to which a photographic print is attached.

Multiplying camera: A camera fitted with multiple lenses used to make multiple exposures on a single plate. Commonly used to make stereographs, *carte-de-visite* prints and **tintypes**.

N

Negative: An image in which the tonality of the subject photographed is reversed. The lightest areas of the subject appear dark, and the darkest areas of the subject appear light. A negative is used to make prints or positive transparencies by contact printing or enlargement.

83

O

Orthochromatic emulsion:
A silver halide emulsion, introduced in 1873, made sensitive to blue and green (but not to red) light by adding colored dyes to the emulsion.

Oxymel: A combination of honey and acetic acid used to preserve sensitized collodion by keeping it moist. *See* **Collodion Negative**.

P

Panchromatic emulsion:
An emulsion introduced in 1904 that is sensitive to all colors of the spectrum (red, green, and blue).

Photogram: A photograph made by placing an object on sensitized paper and exposing it to light. The sheet is then developed and fixed. No camera or lens is needed to make a photogram.

Photomechanical: Processes that translate photographs into prints in ink by chemically transferring the photographic image to a specially prepared metal or glass plate and printing the plate on a printing press. *See* **Collotype**, **Halftone Print**, **Photogravure**, **Woodburytype**.

Pictorialist: An aesthetic movement at the end of the nineteenth century that championed the photograph as a medium for fine art. Pictorialist photographers often used processes that allowed manipulation, such as **gum dichromate**, **platinum**, and **bromoil**, as well as **carbon** and **photogravure**. They experimented with a variety of printing materials and techniques and often manipulated the surface of the print or negative to give the final image a more "painterly" appearance.

Pigment: A mineral or organic substance used as a colorant.

Pigment processes:
Processes that obtain the final image through the use of pigment. *See* **Bromoil Print**, **Carbon Print**, **Carbro Print**, **Gum Dichromate Print**.

Plate size: The size of a metal or glass support used in nineteenth-century processes such as **ambrotype**, **collodion negative**, **daguerreotype**, **gelatin dry plate negative**, and **tintype**. In the early years, plate sizes could vary, but in the United States most were standardized to whole ($6^{1}/_{2} \times 8^{1}/_{2}$ in.), half ($4^{1}/_{4} \times 5^{1}/_{2}$ in.), quarter ($3^{1}/_{4} \times 4^{1}/_{4}$ in.), sixth ($2^{3}/_{4} \times 3^{1}/_{4}$ in.), ninth ($2 \times 2^{1}/_{2}$ in.), and sixteenth ($1^{3}/_{8} \times 1^{5}/_{8}$ in.). Plates larger than the standard whole plate are often referred to as mammoth plates (8×10 to 20×24 in.) The glass for collodion negatives was often hand-cut, so sizes are not always standard. Late nineteenth-century gelatin dry plate negatives in the United States were generally standardized to the following sizes: $3^{1}/_{4} \times 4^{1}/_{4}$, 4×5, $4^{1}/_{4} \times 6^{1}/_{2}$, 5×7, 5×8, $6^{1}/_{2} \times 8^{1}/_{2}$, and 8×10 in.

Positive: A photographic image in correct, rather than inverted, tones, made as a direct positive without the use of a negative, or by contact printing or enlargement from a negative.

Print: A positive photographic image on a paper support.

Positive transparency: A positive image on a transparent support such as glass or film.

Potassium iodide: *See* Halide.

Potassium dichromate:
See Dichromated colloid.

Printing frame: An apparatus used for contact printing, consisting of a sheet of glass fitted into a wooden frame and backed with a flat board, which pressed the negative against the sensitized paper during exposure. Many frames feature a backing board that can be partially opened so that the operator can check the progress of the print without disturbing its alignment with the negative.

Printing-out: The action of sunlight on light-sensitive materials by which an image is made visible. In silver-based processes, the ultraviolet light in sunlight reduces silver chloride into metallic silver, forming the image. Printing-out processes are contact printed. Printing-out differs from developing-out, in which chemical development makes the image visible.

Printing-out papers (P.O.P.):
Photographic papers that are printed-out. *See* Printing-out.

Pyrogallic acid: A photographic developer, also known as "pyro."

R

Red, Green, Blue (RGB):
See Additive color.

Register: The proper alignment of superimposed images. Perfect registration is important in processes that require the manual layering of images, such as **carbon**, **carbro**, **dye imbibition**, and **gum dichromate**.

Resin-coated: Resin-coated, or R.C., paper is coated on the emulsion side with a pigmented polyethylene layer, and on the opposite side with a clear poly-ethylene layer. Polyethylene prevents processing solutions from penetrating the paper base, allowing prints to be processed and dried more quickly. It also prevents the prints from curling. Developed during World War II, resin-coated papers were widely used in the late 1960s. *See* **Gelatin Silver Print.**

Rotogravure: A variation of the **photogravure**, which uses a rotary or cylinder press rather than a plate to produce the image.

Retouching: The manual alteration of a print or negative used to enhance or mask aspects of the image, compensate for imperfect exposure, or correct flaws that result from dust marks or scratches in the negative.

Reversal processing: A technique used to produce a positive transparency from negative film, which is exposed and developed but not fixed, leaving the unexposed silver halides in the film. The negative image is then bleached away and the film is again exposed to light, causing the remaining silver halides to fog. The film is developed a second time, reducing the now-exposed silver halides to metallic silver, producing a positive image.

S

Safelight: A low-wattage, red-filtered light used in a darkroom to provide illumination without interfering with the light sensitivity of orthochromatic gelatin silver print materials.

"Safety film": A variant name for cellulose acetate film, often imprinted along the film's edge to distinguish it from cellulose nitrate film, which is highly flammable.

Salt: *See* Halide.

Salted collodion: Collodion to which iodide has been added. *See* Halide.

Screen plate processes: Color photographic processes in which a sensitized plate is exposed and viewed though a screen bearing a red, green, and blue pattern (lines or dots). Only the light corresponding to the colors on the screen is transmitted to the emulsion. The negative is then reversal-processed to produce a positive transparency. When placed in registration with an identical colored screen and viewed by transmitted light, the image appears in full color. *See* **Autochrome**.

Selenium: *See* Toning.

Sensitize: To add a combination of chemicals to a binder or directly to a paper support, in order to render it sensitive to light. *See* Dichromated colloid, Iron halides, Silver halides.

Separation negatives: A set of three negatives bearing the same image, each photographed through an additive color filter of red, green, or blue. The negatives are printed onto sensitized supports dyed with their corresponding subtractive colors. The red-filtered negative is printed onto the support

dyed cyan, the green printed onto the magenta, and the blue onto the yellow. The positive images are then superimposed to produce a full-color image. *See* **Carbro Print**, **Dye Imbibition Print**.

Silver bromide: *See* Silver halides.

Silver chloride: *See* Silver halides.

Silver halides: The chemical combination of silver nitrate and a halide (chloride, bromide, and/or iodide). Although less commonly used, a silver halide can also be made by combining elemental silver with a halogen (chlorine, bromine, iodine). Many photographic processes are based on the light sensitivity of silver halides, which chemically dissociate and form particles of silver metal in the presence of light energy. *See* **Albumen Print**, **Ambrotype**, **Autochrome**, **Chromogenic Color**, **Collodion Negative**, **Collodion Print**, **Daguerreotype**, **Gelatin Dry Plate Negative**, **Gelatin Silver Print**, **Paper Negative**, **Photogenic Drawing**, **Salted Paper Print**, **Silver Dye Bleach Print**, **Tintype**.

Silver iodide: *See* Silver halides.

Silver mirroring: A common form of deterioration in silver-based photographic processes: silver particles oxidize (owing to air pollution and moisture), migrate to the surface of the binder layer, and are transformed into metallic silver and silver sulfide. Silver mirroring appears as a blue-tinged iridescence in the darkest areas of the print or negative.

Silver nitrate: A crystalline chemical compound ($AgNO_3$) made when silver is dissolved in nitric acid and then evaporated. It is soluble in water, ether, and glycerine. When combined with a halide, it becomes light sensitive. *See* Silver halides.

Silver salts: *See* Silver halides.

Sizing: A substance, usually gelatin or starch, added to paper to limit its absorption. Sizing improves the image quality of photographic processes that require the hand-coating of pigments and light-sensitive chemicals onto paper.

Sodium chloride: *See* Halide.

Sodium thiosulfate: A chemical compound that dissolves silver halides and is used to fix silver-based photographs. Sir John Herschel discovered this property of the compound in 1819 and called the chemical sodium hyposulfite, or "hypo."

Stabilize: To make unexposed silver halides inert, rather than remove them completely by fixing.

Stereograph: Two photographs of the same subject taken from slightly different positions, mounted side by side. When viewed through a stereoscope, the image appears three-dimensional because it triggers binocular vision to superimpose the images. First made using the **daguerreotype** process, stereographs remained popular through the nineteenth and early twentieth centuries. They can be found in most popular print and positive transparency processes.

Stereoscope: An apparatus used to view stereographs.

Subtractive color: Based on the absorption, or subtraction, of light, subtractive color uses the three primary subtractive colors: cyan, magenta, and yellow. Each subtractive color selectively absorbs one primary additive color (red, green, or blue) while allowing the other two colors to be seen; combining all three subtractive colors makes black. Subtractive color principles applied to photography have resulted in the most successful color photographic processes. *See* Carbro Print, Chromogenic Color, **Diffusion Transfer Processes**, **Dye Imbibition Print**, Silver Dye Bleach Print.

Support: A material such as glass, paper, or metal, to which light-sensitive chemicals or photographic emulsions are applied.

T

Tanning: Treating a **gelatin silver print** with a dichromate solution, which selectively hardens the gelatin in proportion to the amount of silver present in the image. Tanning is often done simultaneously with bleaching.

Tipped in: A method of attaching a photograph to a secondary support, typically by using an adhesive on the corners of the print. Often used in the nineteenth and early twentieth centuries to include photographs and photomechanical prints in printed books and other publications.

Toning: Chemically treating a photograph during or after development to alter its appearance or enhance its stability. A solution containing metals such as platinum, sulfur, gold, mercury, uranium, or selenium chemically alters or partially replaces the metal in the photograph (usually silver). In the nineteenth century, gold toning was most common: it was applied to **daguerreotypes** to improve contrast and to printed-out prints to alter their natural reddish or orange-brown hues to more pleasing tones, ranging from purple to blue-black. Developed-out prints could be toned to warm their neutral or cooler tones. The temperature and strength of the toning solution, and the length of toning, affect the final hue.

Transparency: *See* Positive transparency.

U

Ultraviolet light: Ultraviolet, or UV, light is the spectrum of light that produces the photochemical reaction in light-sensitive materials.

W

Weeping Glass: A form of glass deterioration in which beads of moisture form on the surface.

List of
Illustrations

Illustrations are listed alphabetically by artist. With the exception of the last five, all works are from the collection of the National Gallery of Art.

Details on pages ii, v, viii, and 91 are identified with blue page numbers. Illustrations on cover are identified in green.

Works from the Collection of the National Gallery of Art

Robert Adams

Summer Nights #2 (Longmont, Colorado), 1983
gelatin silver print
12.7 × 12.7 cm (5 × 5 in.)
Gift of Mary and David Robinson
© Robert Adams, courtesy of the Fraenkel Gallery, San Francisco and the Matthew Marks Gallery, New York
page 46

American, 19th century

George E. Lane, Jr., c. 1855
ambrotype
10.2 × 8.2 cm (4 × 3 ½ in.)
Gift of Kathleen and Melissa Stegeman
page 12

Portrait of a Man and Child, 1850s, ambrotype
10.2 × 8.2 cm (4 × 3 ½ in.)
Vital Projects Fund
page 12

American, 20th century

"The Artist," c. 1900–1910
cyanotype
9.6 × 12 cm (3 ¼ × 2 ¾ in.)
Gift of Robert E. Jackson
page 33

Eugène Atget

Etang de Corot (Corot's Pond), Ville-d'Avray, 1900–1910
matte albumen print
16.3 × 22.2 cm (6 ⁷⁄₁₆ × 8 ¾ in.)
Patrons' Permanent Fund
page 11

Magasin, Avenue des Gobelins, 1925
gelatin silver print
22.5 × 17.8 cm (8 ⁷⁄₈ × 7 in.)
Patrons' Permanent Fund
page 48

Anna Atkins

Ferns, Specimen of Cyanotype, 1840s
cyanotype
26.3 × 20.8 cm (10 ³⁄₈ × 8 ³⁄₁₆ in.)
R. K. Mellon Family Foundation Fund
page 32

Harry Callahan

Providence, 1977
dye imbibition print
22.7 × 32.7 cm (8 ¹⁵⁄₁₆ × 12 ⁷⁄₈ in.)
Gift of Mr. and Mrs. David C. Ruttenberg, Courtesy of the Ruttenberg Arts Foundation
© Estate of Harry Callahan, courtesy Pace/MacGill Gallery, New York
page 40

Etienne Carjat

Charles Baudelaire, 1861
Woodburytype, printed in 1877
23.1 × 18.1 cm (9 ⅛ × 7 ⅛ in.)
Gift of Jacob Kainen
page 76

J. G. Ellinwood

Portrait of a Woman, c. 1870
tintype, hand-colored
21.3 × 14.9 cm (8 ³⁄₈ × 5 ⁷⁄₈ in.)
Mary and Dan Solomon Fund
page 74

Roger Fenton

Fruit and Flowers, 1860
albumen print
35.5 × 43 cm (14 × 16 ¹⁵⁄₁₆ in.)
Paul Mellon Fund
page 8

Robert Fichter

Look Out Baby, c. 1982
silver dye bleach print
99.6 × 80.5 cm (39 ³⁄₁₆ × 31 ¹¹⁄₁₆ in.)
Gift of Marc Freidus
page 72

Robert Frank

Chauffeur/London, 1951
gelatin silver print
22 × 33.1 cm (8 11/16 × 13 1/16 in.)
Robert Frank Collection,
Gift (Partial and Promised)
of Robert Frank, in Honor
of the 50th Anniversary of
the National Gallery of Art
© Robert Frank
page 51

Laura Gilpin

*Ghost Rock, Colorado
Springs*, 1919
platinum print
24.2 × 19.1 cm (9 1/2 × 7 1/2 in.)
Marvin Breckinridge
Patterson Fund, © 1979
Amon Carter Museum,
Fort Worth, Texas
page 69

Johan Hagemeyer

Pedestrians, 1921
gelatin silver print
22.2 × 17.6 cm (8 11/16 × 6 15/16 in.)
Marvin Breckinridge
Patterson Fund
and The Amy Rose
Silverman Fund
page 91

**David Octavius Hill
and Robert Adamson**

James Drummond, c. 1844
salted paper print
19.4 × 14.3 cm (7 5/8 × 5 5/8 in.)
Funds from an
Anonymous Donor
page 70

**Baron Louis-Adolphe
Humbert de Molard**

The Bean Sorters, c. 1857
paper negative
23.4 × 18.3 cm (9 3/16 × 7 3/16 in.)
Funds from an
Anonymous Donor
page 58

Yasuhiro Ishimoto

Page 121, from *Chicago,
Chicago* (Tokyo, 1969),
halftone print
(offset lithograph)
page 56

Gertrude Käsebier

Mother and Child, c. 1900
multiple gum dichromate print
27.9 × 17.7 cm (11 × 7 in.)
Patrons' Permanent Fund
page 52

André Kertész

Sleeping Boy, 1912
gelatin silver print
4.4 × 5.9 cm (1 3/4 × 2 5/16 in.)
Gift of The André and Elizabeth
Kertész Foundation
page 49

Heinrich Kühn

*Die Schnitterin
(The Reaper)*, 1924
bromoil transfer print
28.2 × 21.5 cm (11 1/8 × 8 7/16 in.)
Diana and Mallory
Walker Fund
page 16, cover

Helen Levitt

New York, 1980
chromogenic color print
20.5 × 25.4 cm (8 1/16 × 10 in.)
Gift of Marvin Hoshino in
memory of Masao W. Hoshino
page 22, cover

Robert Mapplethorpe

Self-Portrait (with Dancer),
1974, diffusion transfer print
11 × 8.9 cm (4 5/16 × 3 1/2 in.)
Glenstone in honor of Eileen
and Michael Cohen
© The Robert Mapplethorpe
Foundation. Courtesy
Art + Commerce
page 36

Gordon Matta-Clark

Conical Intersect, 1975
silver dye bleach print
76.2 × 101.6 cm (30 × 40 in.)
The Glenstone Foundation,
Mitchell P. Rales, Founder
page 73

László Moholy-Nagy

Untitled, c. 1922–1924
gelatin silver print
23.8 × 17.8 cm (9 3/8 × 7 in.)
New Century Fund
page 50, cover

Untitled (positive),
c. 1922–1924
gelatin silver print
23.7 × 17.8 cm (9 5/16 × 7 in.)
Gift of The Circle of
the National Gallery of Art
page ii

Eadweard Muybridge

Cockatoo Flying,
detail of plate 758,
from *Animal Locomotion*
(University of Pennsylvania,
Philadelphia, 1887)
collotype
20.3 × 36.8 cm (8 × 14 1/2 in.)
Gift of Mary and Dan Solomon
and Patrons' Permanent Fund
page 30

Charles Nègre

*Chartres Cathedral,
South Transept*, c. 1854
photogravure
59.3 × 80 cm (23 3/8 × 31 1/2 in.)
William and Sarah
Walton Fund
page 62

*Château de Vallambrosa,
Cannes*, c. 1852
waxed paper negative
24 × 33 cm (9 7/16 × 13 in.)
Gift of Charles Isaacs
and Carol Nigro in memory
of Diamon Gangji
page 58

Oscar Gustave Rejlander

Ariadne, 1857
albumen print
20.4 × 15.5 cm (8 1/16 × 6 1/8 in.)
Paul Mellon Fund
page 10

Franz Roh

Negative Nude, 1920s/1930s
gelatin silver print
21.5 × 15.4 cm (8 7/16 × 6 1/16 in.)
Patrons' Permanent Fund
page v

89

Stephen Shore

Holden Street, North Adams, Massachusetts, July 13, 1974
chromogenic color print
20.5 × 25.4 cm (8 1/16 × 10 in.)
Diana and Mallory
Walker Fund
page 22

Albert Sands Southworth and Josiah Johnson Hawes

The Letter, c. 1850
daguerreotype
20.3 × 15.2 cm (8 × 6 in.)
Patrons' Permanent Fund
page 34

Edward Steichen

Cover Design, 1906
halftone print (duotone)
38.7 × 15.7 cm (15 1/4 × 6 3/16 in.)
Anonymous Gift
page 54

Alfred Stieglitz

Unknown Woman, 1907
Autochrome
12 × 16.9 cm (4 3/4 × 6 5/8 in.)
Alfred Stieglitz Collection
page 14

A Wet Day on the Boulevard, Paris, 1894
carbon print
17.2 × 29.7 cm (6 3/4 × 11 11/16 in.)
Alfred Stieglitz Collection
page 18

The Terminal, 1893
photogravure, printed in or before 1913
25.5 × 33.6 cm
(10 1/16 × 13 1/4 in.)
Alfred Stieglitz Collection
page 64

Karl Struss

Columbia University, Night, 1910
gum dichromate over platinum print
24 × 19.4 cm (9 7/16 × 7 5/8 in.)
The Horace W. Goldsmith Foundation through Robert and Joyce Menschel
page 68

William Henry Fox Talbot

Oak Tree, mid-1840s
salted paper print
22.5 × 18.7 cm (8 7/8 × 7 3/8 in.)
Patrons' Permanent Fund
page viii

Lace, 1839–1844
photogenic drawing
17.1 × 22 cm (6 3/4 × 8 11/16 in.)
Patrons' Permanent Fund
page 60

Adam Clark Vroman

In the Petrified Forest (General View, Middle Park), c. 1895–1897
collodion print
15.2 × 20.3 cm (6 × 8 in.)
Gift of Mary and Dan Solomon
page 28

Andy Warhol

Self-Portrait with Fright Wig, 1986
dye diffusion transfer print
9.2 × 7.2 cm (3 5/8 × 2 13/16 in.)
Glenstone in honor of Eileen and Michael Cohen
© 2009 The Andy Warhol Foundation for the Visual Arts/ARS, New York
page 38, cover

Edward Weston

The Breast (The Source), 1921
palladium print
19.1 × 23.5 cm (7 1/2 × 9 1/4 in.)
Patrons' Permanent Fund
page 66

Works from Other Collections

David Applegate

Exposed strip of Tri-X film, 2009
Courtesy of the artist
page 42

Anne W. Brigman

The Heart of the Storm, 1906
gelatin dry plate negative
25.4 × 20.3 cm (10 × 8 in.)
Courtesy of George Eastman House, International Museum of Photography and Film
page 44

Roger Fenton

The Princess Royal and Princess Alice, August 1855
wet collodion negative
45 × 37.5 cm (17 1/10 × 14 4/5 in.)
The Royal Collection
© 2009 Her Majesty Queen Elizabeth II
page 24

The Princess Royal and Princess Alice, August 1855
albumen print
33.8 × 28.1 cm (13 3/10 × 11 1/10 in.)
The Royal Collection
© 2009 Her Majesty Queen Elizabeth II
page 26

Nickolas Muray

Frida Kahlo, c. 1938
carbro print
37 × 29.5 cm (14 9/16 × 11 5/8 in.)
Courtesy of George Eastman House, International Museum of Photography and Film, © Nickolas Muray Photo Archives
page 20

Suggested
Reading

General

Baldwin, Gordon. *Looking at Photographs: A Guide to Technical Terms.* Malibu, 1991.

Barnier, John. *Coming into Focus: A Step-by-Step Guide to Alternative Printing Processes.* San Francisco, 2000.

Benson, Richard. *The Printed Picture.* New York, 2008.

Coe, Brian. *Colour Photography: The First Hundred Years, 1840–1940.* London, 1978.

Coe, Brian, and Mark Haworth-Booth. *A Guide to Early Photographic Processes.* London, 1983.

Coote, Jack Howard Roy. *The Illustrated History of Colour Photography.* Surbiton, 1993.

Crawford, William. *The Keepers of Light: A History & Working Guide to Early Photographic Processes.* Dobbs Ferry, NY, 1979

Davis, Keith F. *The Origins of American Photography 1839–1885: From Daguerreotype to Dry-Plate.* New Haven, 2007

Friedman, Joseph S. *History of Color Photography.* 2nd ed. New York, 1968.

Frizot, Michel, ed. *A New History of Photography.* Cologne, 1998.

Gascoigne, Bamber. *How to Identify Prints: A Complete Guide to Manual and Mechanical Processes from Woodcut to Ink Jet.* London, 1986.

Hannavy, John, ed. *Encyclopedia of Nineteenth-century Photography.* New York, 2007.

James, Christopher. *The Book of Alternative Photographic Processes.* New York, 2002.

Lavédrine, Bertrand. *(Re)Connaître et conserver les photographies anciennes.* Paris, 2007.

Leyshon, William E. *Photographs from the 19th Century: A Process Identification Guide.* Prescott, AZ, 1984–2001. *http://www.sharlot.org/archives/photographs/19th/leyshon.pdf/.*

McCabe, Constance, ed. *Coatings on Photographs: Materials, Techniques, and Conservation.* Washington, 2005.

Mora, Gilles, ed. *Photospeak.* New York, 1998.

Nadeau, Luis. *Encyclopedia of Printing, Photographic, and Photomechanical Processes: A Comprehensive Reference to Reproduction Technologies, Containing Invaluable Information on Over 1500 Processes.* Fredericton, New Brunswick, 1989–1990.

Peres, Michael R., ed. *The Focal Encyclopedia of Photography: Digital Imaging, Theory and Applications, History, and Science.* 4th ed. Boston, 2007.

Reilly, James M. *Care and Identification of 19th-century Photographic Prints.* Rochester, 1986.

Individual Processes

Arentz, Dick. *Platinum and Palladium Printing.* Boston, 2000.

Barger, Susan M., and William B. White. *The Daguerreotype: Nineteenth-century Technology and Modern Science.* Washington, 1991.

Oliver, Barret. *A History of the Woodburytype: The First Successful Photomechanical Printing Process and Walter Bentley Woodbury.* Nevada City, CA, 2007.

Olshaker, Mark. *The Instant Image: Edwin Land and the Polaroid Experience.* New York, 1978.

Reilly, James M. *The Albumen and Salted Paper Book: The History and Practice of Photographic Printing, 1840–1895.* Rochester, 1980.

Rinhart, Floyd, Marion Rinhart, and Robert W. Wagner. *The American Tintype.* Columbus, OH, 1999.

Schimmelman, Janice Gayle. *The Tintype in America, 1856–1880.* Philadelphia, 2007.

Scopick, David. *The Gum Bichromate Book: Non-silver Methods for Photographic Printmaking.* 2nd ed. Boston, 1991.

Ware, Mike. *Cyanotype: The History, Science and Art of Photographic Printing in Prussian Blue.* London, 1999.

Wood, John. *The Art of the Autochrome: The Birth of Color Photography.* Iowa City, 1993.

Wood, John, ed. *The Daguerreotype.* Iowa City, 1989.

Acknowledgments

Sarah Kennel

The slimness of this volume belies the tremendous amount of work and dedication that my colleagues at the National Gallery of Art and elsewhere have devoted to it and I owe them my deepest gratitude. I am indebted to director Earl A. Powell III and deputy director Franklin Kelly for their support of this book and the overall photography program at the National Gallery.

In the department of photographs, I wish to thank Sarah Greenough, senior curator and head of the department, for her steadfast encouragement and wise counsel throughout the many phases of this project. Assistant curator Diane Waggoner conceptualized the book with me and wrote a number of entries — with precision, grace, and timeliness. Graduate fellow Alice Carver-Kubik enthusiastically accepted the challenge of drafting text on color processes, completing the glossary, and compiling the bibliography, while also providing excellent research. Former interns Mazie Harris and Tessa Paneth-Pollack worked tirelessly to compile research files, hunt down sources, answer queries, and draft the glossary and time line. Former intern Yali Lewis provided helpful preliminary work. Curatorial assistant Kathleen McGovern offered cheerful, efficient administrative support.

My coauthors and I are extremely grateful to our colleagues in the paper conservation department of the National Gallery for their guidance and support. Their illuminating technical examinations of photographic materials and their assistance with microphotography have helped us understand and accurately identify various prints.

This undertaking has benefited from the expertise and goodwill of colleagues at other institutions, including Joe R. Struble, Jamie M. Allen, and Barbara Galasso at the George Eastman House; Sophie Gordon and Karen Lawson at the Royal Collection, John Rohrbach and Jessica May at the Amon Carter Museum, and Roger Taylor at De Montfort University. Sarah Wagner, photograph conservator, also shared her time and expertise. A huge debt of gratitude is owed to photograph conservator Gawain Weaver, who brought a vast knowledge of the technical and historical aspects of photographic processes to bear on the manuscript. His careful reading not only flushed out inconsistencies but greatly deepened our technical knowledge and precision; any errors that remain are the responsibility of the authors.

This book was initially conceived as a small brochure. Its journey to book form is owed to the sustained enthusiasm, support, and hard work of the publishing group at the National Gallery. Judy Metro, editor in chief, deserves special thanks for her dedication to this project and her thoughtful guidance at every step along the way. We thank Mary Yakush for her superb editing, accomplished with skill, discernment, and tact under tight deadlines. Margaret Bauer, whose innovative and beautiful design has brought this book to life in an extraordinary way, deserves our deep gratitude. Without Robert J. Hennessey's skill at interpreting photographs to make sensitive, accurate separations, and his knowledge of offset printing technologies, this book would serve little purpose. Chris Vogel, assisted by John Long, worked with perseverance and well-honed skill to oversee the production of this book. With her characteristic calm efficiency, Sara Sanders-Buell secured images and rights for this volume. Program assistant Daniella Berman deserves particular recognition for her enthusiastic and efficient organization of myriad tasks. We also thank Martha Vaughan who skillfully created, and patiently revised, the technical drawings.

Other departments of the National Gallery of Art contributed to the success of this endeavor. In the development office, we are especially grateful to Patricia Donovan, senior development associate, who secured critically important funding for this book. In the department of imaging and visual services, we thank Lorene Emerson, head of photographic services, David Applegate, digital imaging specialist, and photographers Dean Beasom, Lee Ewing, and Ricardo Blanc, all of whom worked extremely hard to produce the images printed here.

Finally, and by no means least, we would like to express our sincere appreciation to The Robert Mapplethorpe Foundation, Inc., for its generous grant in support of this publication. We are especially grateful to the foundation's president, Michael Ward Stout, and his fellow trustees for their longstanding dedication to the National Gallery's photography program.

Index of Variant Names

Entries are cross-referenced to the process names used in this guide and include related processes as well as variant names.